D1129104

POSTCARD HISTORY SERIES

Louisville

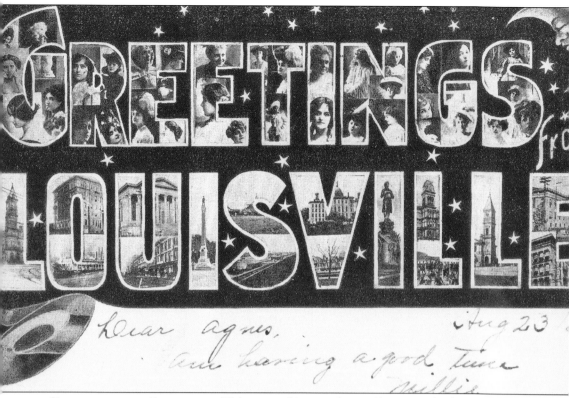

Dear agnes,
are having a good time
nellie
Aug 23

GREETINGS FROM LOUISVILLE. This postcard is one of many "greetings from" cards that were produced for cities and towns. This black-and-white card contains many images of Louisville and attractive women within the letters. (Courtesy of the author.)

POSTCARD HISTORY SERIES

Louisville

John E. Findling

ARCADIA
PUBLISHING

Published by Arcadia Publishing
Charleston, South Carolina

Printed in the United States of America

Library of Congress Control Number: 2009922284

For all general information contact Arcadia Publishing at:
Telephone 843-853-2070
Fax 843-853-0044
E-mail sales@arcadiapublishing.com
For customer service and orders:
Toll-Free 1-888-313-2665

Visit us on the Internet at www.arcadiapublishing.com

*For Emerson James Findling, in the hope that he
will one day enjoy the tales of history told by postcards*

CONTENTS

ACKNOWLEDGMENTS

This book is an outgrowth of my affection for a city that I have lived in or near for more than 35 years and of my interest in the historical stories that vintage postcards have to tell. But projects such as this can never be done without the help of others. I want to thank Luke Cunningham of Arcadia Publishing for his relentless cheerfulness and enthusiasm about a Louisville postcard book and others at the company for their attentiveness to the questions I had along the way.

I want also to thank my partners in Collectors' Stamps, Ltd., where most of the postcards came from, including Jerry Hornung, Bob Moore, Elmer Susemichel, and Leland Bell for their assistance and support, and I especially want to express my appreciation to Louis Cohen of Louisville, who graciously allowed me to borrow postcards from his collection to fill in the many gaps that my own postcards left. Thanks, too, to Rick Bell, the director of the U.S. Marine Hospital, for the image of that historic structure and to Jerry Hornung for the Oertel's Beer postcard. Unless otherwise noted, all images appearing are courtesy of the author.

A number of local historians read parts of the manuscript and kindly pointed out my glitches and made valuable suggestions for improvement. Thanks to Tom Owen and Charles Castner of the University of Louisville Archives, as well as David Barksdale, Carl Kramer, Carol Tobe, and Gary Falk for taking the time to do this. Thanks also to Kim Pelle, my longtime editing partner, for a general proofreading of the caption material. Kathie Johnson of the University of Louisville Archives, Betty Menges of the Indiana Room at the New Albany-Floyd County Public Library, and several staff members of the Louisville Free Public Library were very helpful in finding bits of information that I needed for the captions. I am grateful to Andy Anderson, Gregg Seidl, Frank Thackeray, and members of both the Louisville Historical League and the Louisville Postcard Club for their interest in this project, and as always, I benefited from the loving support of my wife, Carol, throughout the process. Thank you to all.

INTRODUCTION

More than 200 postcard (and a few non-postcard) images are included in this book, which is designed to show the development of Louisville commercially, culturally, and indeed geographically between 1905 and 1940. This span of years defines the great era of the picture postcard in the United States, when people routinely used postcards as their principal means of communication with family and friends who lived out of town. Telephone service was spotty and expensive, the Internet had not yet been invented, and the postage rate for postcards during most of this period was just 1¢—one could not find a better deal. This span of years also defines a critical time in Louisville's historical development. The city's commerce shifted from dependence on the river to linkages with railroads, residences virtually disappeared from the downtown core, and neighborhoods, businesses, and attractions began to develop miles from the city center because of the availability of trolleys, buses, and later, private automobiles. By 1940, Louisville was, like many other American cities, a vastly different place than it had been 35 years earlier.

This book has been organized geographically rather than topically like many of the other fine books in this series. I chose to arrange the chapters this way in order to show how Louisville first developed along the three major streets next to the river (Main, Market, and Jefferson Streets), gradually moved south down Fourth Street, then to Broadway and the area known as Old Louisville, and after that, to areas west, south, and east of the city center. Two final chapters deal with the Ohio River and the southern Indiana communities across the river: New Albany, Clarksville, and Jeffersonville, whose own histories are closely related to that of Louisville. The index will be helpful in bringing together images of topics that might otherwise have been in a single chapter, such as the 1937 Ohio River flood.

Some comments on street names and numbers may be helpful in clarifying otherwise confusing issues. Over the years, several major streets in Louisville have had name changes. Green Street became Liberty Street in 1918, and Walnut Street became Muhammad Ali Boulevard in 1978. Other street name changes are noted in individual captions. While its official name is Fourth Street, many Louisvillians referred to it as Fourth Avenue because, according to one local historian, it sounded more elegant. In 1909, the city government undertook to change all the street numbers in Louisville in order to make them consistent from block to block. In this book, the present street numbers have been used, even though some of the postcard images pre-date the numbering changeover. Finally, the book uses the phrases "west of downtown," "south of downtown," and "east of downtown," instead of the locally popular "west end," "south end," and "east end." This is because the local phrases carry cultural connotations that to

some are not always flattering, and because the boundaries of these areas are not easy to define, especially since Louisville and Jefferson County merged in 2003 and formed a metropolitan Louisville government.

Postcard images do not tell the entire history of a city such as Louisville. While most of the prominent buildings, leading institutions, and major streets were immortalized on a postcard, much of the city was ignored by postcard publishers who, naturally enough, saw no profit in publishing a picture of a dirty alley, a rundown neighborhood, or a crowd at a corner bar. Postcards, therefore, tell only a portion of Louisville's history, albeit a significant one. Other books, with other kinds of images, some published in Arcadia Publishing's other series, will help to complete the picture.

One

DOWNTOWN
MAIN, MARKET, AND
JEFFERSON STREETS

Until the 1890s or so, most of Louisville's goods and many of its visitors arrived on steamboats that docked on the river's edge between present day Third and Sixth Streets. As a consequence, Main, Market, and Jefferson Streets became the center of business and social activity for Louisville from the city's founding in 1778 until the last years of the 19th century. Louisville's most elegant hotels, such as the Galt House and the Louisville Hotel, were built on Main Street, its city hall and courthouse rose up on Jefferson Street, and the city's first skyscrapers, the Columbia Building, the Lincoln Building, and the Todd Building, occupied street corners on Main and Market Streets. The postcard images in this chapter illustrate some of the more important buildings of this district and attempt to convey the activity that made these streets so important in this era.

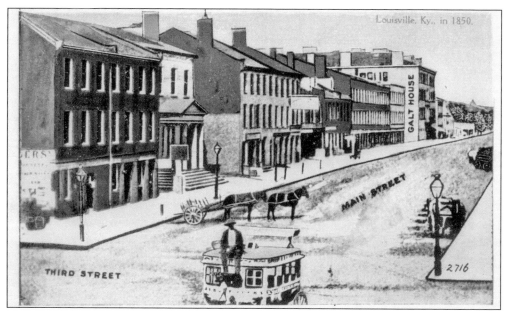

LOUISVILLE IN 1850. This postcard purports to show a view of Main Street east from Third Street in 1850. The only identified building is the Galt House, the first hotel by that name, built in about 1835 and located at Second and Main Streets. The third building from the corner of Third and Main Streets, with the Greek Revival front, is the Bank of Kentucky. The omnibus in the foreground transported passengers between Louisville and Portland.

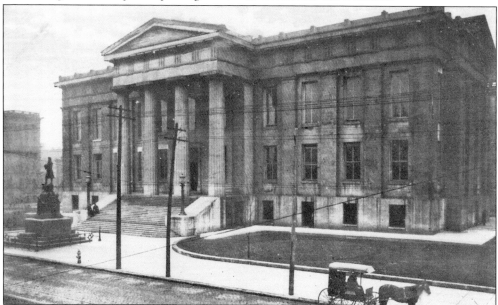

JEFFERSON COUNTY COURTHOUSE. Designed by Gideon Shryock, the courthouse was built between 1835 and 1859 on Jefferson Street between Fifth and Sixth Streets. Shryock's original design called for a cylindrical dome on the top, but this was never executed. The roof burned in 1905, causing the county government to replace all interior wood with metal. In the late 1940s, the courthouse was slated for demolition, but it was spared and continues to serve the community.

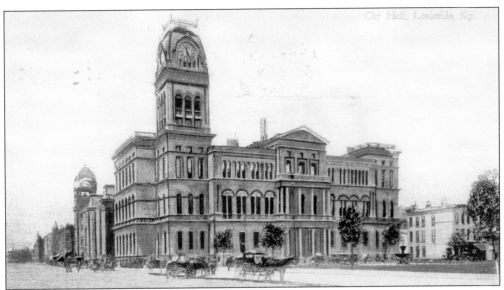

CITY HALL. Located on the northwest corner of Sixth and Jefferson Streets, the city hall was completed in 1873 at a cost of $464,778. John Andrewartha and C. S. Mergell designed the building in the then very popular French Second Empire style, adding some Italianate details, and the exterior contains numerous carvings emblematic of Louisville and its belief in progress. The clock tower, designed by Henry Whitestone, was added in 1876 to replace the original that had burned the year before. The structure now serves as the Louisville Metro Government center.

LOUISVILLE HOTEL. Located on the south side of Main Street between Sixth and Seventh Streets, the elegant Louisville Hotel opened in 1833. Hugh Roland designed it, installing an impressive bank of 10 Ionic columns along the front. An 1853 expansion, carried out by local architect Henry Whitestone and Isaiah Rogers from Boston, extended the hotel around the corner onto Sixth Street and removed the colonnade. The hotel closed in 1938 and was razed in 1949.

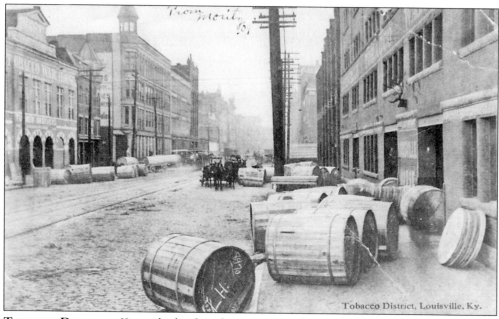

TOBACCO DISTRICT. Kentucky has long been a major tobacco-growing state, and Louisville's proximity to the Ohio River made it a center for the storage and shipment of the crop as well as for the manufacture of tobacco products. A tobacco district developed along Main Street between Eighth and Twelfth Streets by the 1880s. As the postcard image shows, warehouses lined the north side of the street for easy access to the wharves along the river.

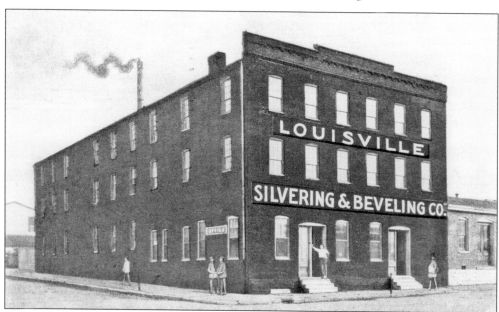

LOUISVILLE SILVERING AND BEVELING. Other small businesses developed near the Ohio River. The Louisville Silvering and Beveling Company, located at 1334 Washington Street, was typical of these enterprises. It made mirrors and fancy glass pieces around 1910 when the postcard is postmarked. By 1915, it had disappeared from the city directory, and the property was vacant. (Courtesy of Louis Cohen.)

COLUMBIA BUILDING. Located at Fourth and Main Streets, the Columbia Building was Louisville's first true skyscraper. The 10-story tower was constructed of red brick in the Richardsonian Romanesque style at a cost of $1 million, and it was the tallest building in the city for 10 years after its completion in 1891. Demolished in 1966, it was replaced by the 24-story Commonwealth Bank and Trust Building, now known as One Riverfront Plaza.

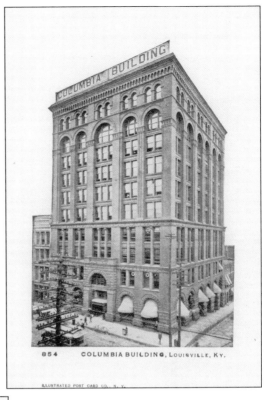

854 COLUMBIA BUILDING, LOUISVILLE, KY.

ILLUSTRATED POST CARD CO., N. Y.

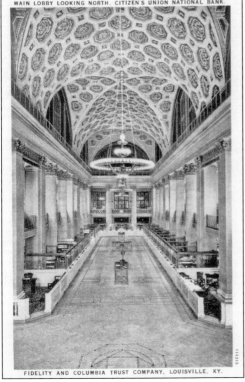

MAIN LOBBY LOOKING NORTH. CITIZEN'S UNION NATIONAL BANK.

FIDELITY AND COLUMBIA TRUST COMPANY, LOUISVILLE, KY.

COLUMBIA BANK, LOBBY. Among other things, the Columbia Building housed the Columbia Bank, and this postcard image shows the typically ornate interior of palaces of money in the 1920s.

13

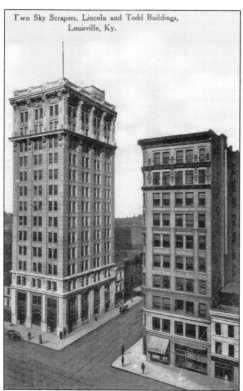

Two Sky Scrapers, Lincoln and Todd Buildings, Louisville, Ky.

LINCOLN AND TODD BUILDINGS. By the first decade of the 20th century, the Lincoln Building (sometimes referred to as the Washington Building) and the Todd Building, across the street from one another at Fourth and Market Streets, overshadowed the Columbia Building. The Todd Building dates from 1901. The taller Lincoln Building was built in 1906 and was torn down as part of an urban redevelopment plan in 1972. The Todd Building was razed in 1983 to make space for a parking garage.

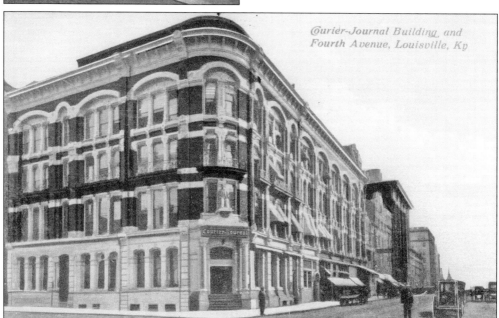

Courier-Journal Building, and Fourth Avenue, Louisville, Ky

COURIER-JOURNAL BUILDING. Located at Fourth and Green (now Liberty) Streets, this building was erected in 1878 for the Louisville *Courier-Journal*. After the newspaper moved a block away in 1912, Will Sales Jewelers moved into the building, which then became known as the Will Sales Building until it was demolished in 1979 after an unsuccessful battle to preserve it. The Brown and Williamson Tower now stands on the site.

LEVY'S AT NIGHT. Located on the northeast corner of Third and Market Streets, the Levy Brothers building remains a Louisville landmark. The building was opened in 1893 as a retail clothing store. In 1908, it was festooned with electric lights, and the city adopted the slogan, "Lit Up Like Levy's." Levy Brothers went out of business in 1979, and the building was renovated to accommodate a restaurant on the ground floor and offices and condominiums on the upper floors.

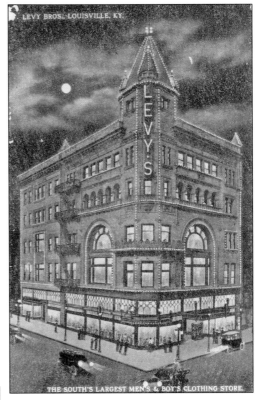

LEVY BROS., LOUISVILLE, KY.

THE SOUTH'S LARGEST MEN'S & BOY'S CLOTHING STORE.

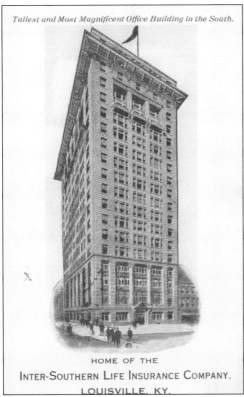

Tallest and Most Magnificent Office Building in the South.

HOME OF THE
INTER-SOUTHERN LIFE INSURANCE COMPANY,
LOUISVILLE, KY.

INTER-SOUTHERN BUILDING. The Inter-Southern Life Insurance Company commissioned Brinton B. Davis to design this neoclassical skyscraper at the northeast corner of Fifth and Jefferson Streets. It opened in 1913 and contained law offices as well as the company's headquarters. A 1926 advertisement for Inter-Southern termed the company "clean, strong, progressive," and a major expansion was completed around that time, but by 1933, Inter-Southern was gone. The building was renamed the Kentucky Home Life Building, and it still functions as an office building.

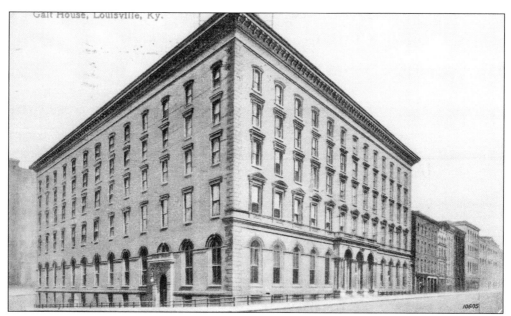

THE GALT HOUSE. This image shows the second Galt House, located at First and Main Streets between 1869 and 1921, when it was razed to make way for the Belknap Hardware complex. The first Galt House, at Second and Main Streets, had burned in 1865. The hotel, designed by local architect Henry Whitestone, was perhaps the most elegant in the city. When the commercial center of the city moved south, the Galt House went into a slow decline until it closed in 1919.

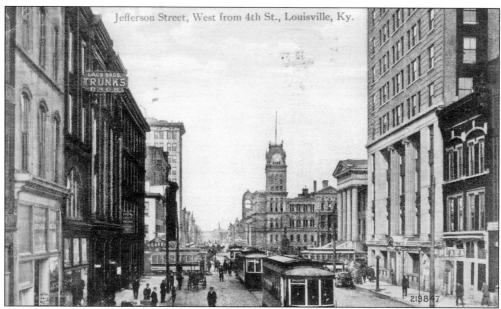

JEFFERSON STREET, WEST FROM FOURTH STREET. In this image from the middle of the second decade of the 20th century, the courthouse and city hall are clearly recognizable on the right, and the tall building in the right foreground (at the corner of Jefferson Street) is the Inter-Southern Building. The large building on the left, across from the courthouse, is the Willard Hotel, one of Louisville's oldest, dating back to the 1850s.

MARKET STREET, EAST FROM FOURTH STREET. In this image from about 1918, the Lincoln Building and the Todd Building dominate the streetscape with Levy Brothers, the men's clothing store, visible a block farther east. The Western Union telegraph offices, J. C. McBurnie's saloon, several furniture stores, and Goby's American Restaurant are west of the Lincoln Building.

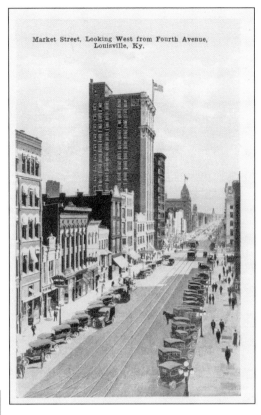

Market Street, Looking West from Fourth Avenue, Louisville, Ky.

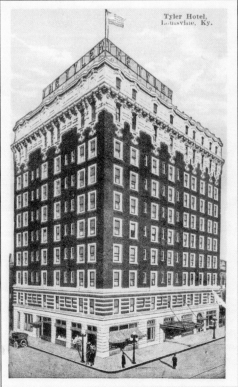

Tyler Hotel, Louisville, Ky.

THE TYLER HOTEL. The Tyler Hotel opened in 1910 at Third and Jefferson Streets, and for many years it was the only major hotel in the northern part of downtown. The hotel became the Earle Hotel in the late 1940s and then the Milner Hotel in the early 1960s after its new owner, Earle Milner. In the 1970s, it was torn down to make space for the Kentucky International Convention Center.

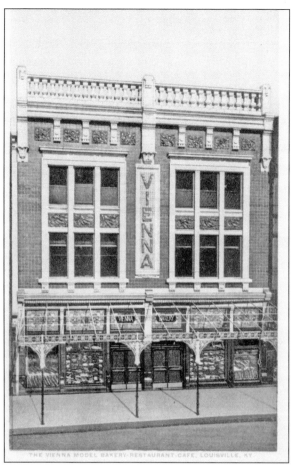

VIENNA MODEL BAKERY.
Renowned for its decorative terra-cotta facade created by Rookwood Pottery of Cincinnati, this European-style bakery and restaurant was a popular spot after it opened in 1895 at 133 South Fourth Street until it closed in 1927. Frank L. Erpeldinger, a German immigrant, founded the bakery and restaurant and introduced Louisvillians to his German and Austrian specialties. The interior was furnished with oak tables and chairs from Austria, paneled walls, and ceiling fans. The kitchen and bakery were on the second floor, and a pastry department occupied the top floor. After years of vacancy, the building became the Democratic Party headquarters in 1951. It was razed in the mid-1980s to clear space for a parking garage. (Courtesy of Louis Cohen.)

THE VIENNA MODEL BAKERY-RESTAURANT-CAFE, LOUISVILLE, KY.

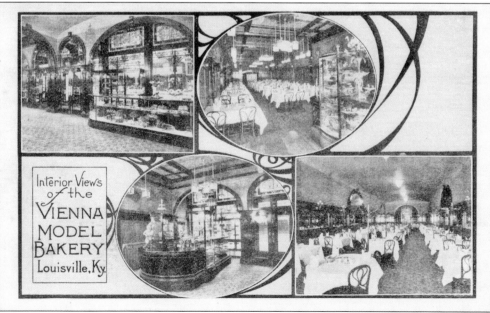

Interior Views of the VIENNA MODEL BAKERY Louisville, Ky.

M. COHEN AND SONS, FOLLOW-UP GIRL. M. Cohen and Sons was a prominent men's store for more than 20 years. After 1918, the store was at 300 West Market Street. This postcard from the 1920s was an early effort to use pretty women as an advertising lure for male customers. By 1931, M. Cohen and Sons was gone, and a new store, Town Talk Clothes, was at the Market Street location. (Courtesy of Louis Cohen.)

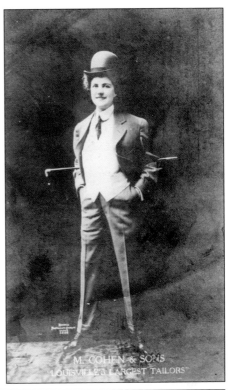

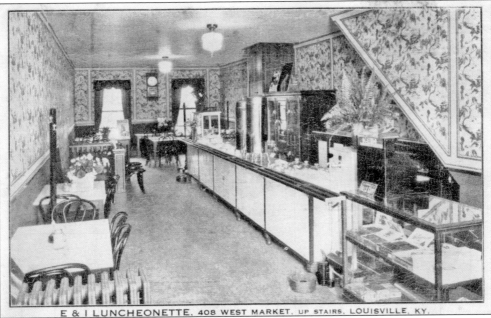

E&I LUNCHEONETTE. Many small restaurants sprang up (and quickly disappeared) in downtown Louisville during this era. Most did not appear and then disappear as quickly as the E&I Luncheonette, located upstairs at 408 West Market Street. Owned by Joe Eichele, who had a men's store at the same address, and Will Irion, whose family ran a jewelry store next door, the luncheonette was open for only about a year in the late 1920s. (Courtesy of Louis Cohen.)

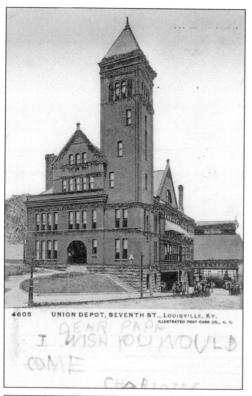

4605 UNION DEPOT, SEVENTH ST., LOUISVILLE, KY.
 ILLUSTRATED POST CARD CO., N. Y.

DEAR PAPA
I WISH YOU WOULD
COME
CHARLOTTE

UNION DEPOT. Located at Seventh and Main Streets, this railroad station was built shortly after the devastating tornado of March 27, 1890, ripped through part of downtown Louisville. Later it was known as the Seventh Street Depot and still later as Central Station. By the 1950s, it had ceased functioning as a train station, and the Illinois Central railroad maintained offices there until the early 1960s. Its final tenant was Actors' Theatre of Louisville, which used it from 1966 until the early 1970s.

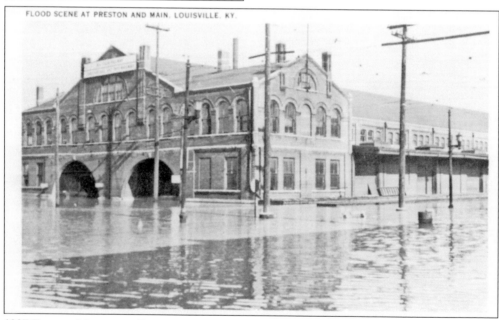

FLOOD SCENE AT PRESTON AND MAIN, LOUISVILLE, KY.

1937 FLOOD, MAIN AND PRESTON STREETS. Although the downtown streets close to the river did not suffer as much from the flood as other parts of the city, rising waters did cause problems. This postcard shows the flooded warehouse of the Brinly-Hardy Company, manufacturers of farm equipment, at Main and Preston Streets just east of downtown. This structure was adapted into a stadium for the Louisville Bats minor-league baseball team in 1998.

Two

DOWNTOWN
FOURTH AND WALNUT STREETS

This section of downtown Louisville centered around Fourth and Walnut Streets, including Second, Third, and Fifth Streets running north and south, and Chestnut Street running east and west. This area became the center of downtown life after the opening of the grand Seelbach Hotel at Fourth and Walnut Streets in 1905. The movement away from the northern part of downtown had already begun with the opening of Union Depot (often called Union Station) at Tenth Street and Broadway in 1892, signaling the triumph of rail over river. Over the next 20 years, Fourth Street was transformed into a lively commercial and cultural center with the construction of newer, more modern office buildings, theaters, and, in the 1920s, movie palaces. In homage to what Fourth Street once was, the city has given strong backing to various projects to revitalize the street. River City Mall turned Fourth Street into a pedestrian walkway in the 1970s, the Galleria came with a rakishly slanted glass roof over part of the street in the 1980s, and most recently, Fourth Street Live is an effort to turn Fourth Street into an upscale entertainment area.

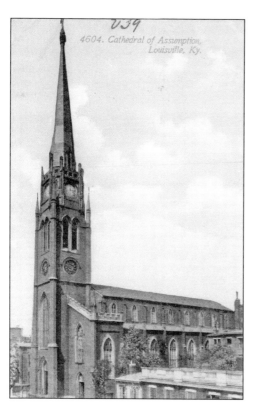

CATHEDRAL OF THE ASSUMPTION. Long before Fourth Street became the center of downtown, Louisville's two cathedrals brought people to the area. The Catholic Cathedral of the Assumption, located at Fifth and Walnut Streets, was constructed between 1849 and 1852 of brick covered with stucco to simulate stone and satisfy the need for an appropriate building after the diocese was moved to Louisville in 1841. A major restoration project in the mid-1980s brought the cathedral back to its former glory.

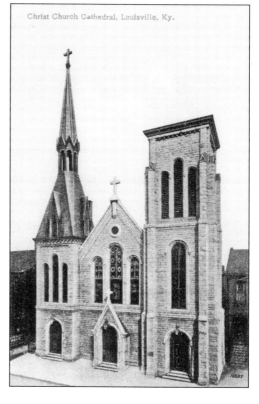

CHRIST CHURCH CATHEDRAL. Located on Second Street between Green and Walnut Streets, this Episcopalian church, which became a cathedral in 1894, was erected in 1824 and expanded in 1846, 1859, and 1870. Local architect William H. Redin designed the last two additions. In the 1890s, the structure was completed with the installation of stained-glass windows.

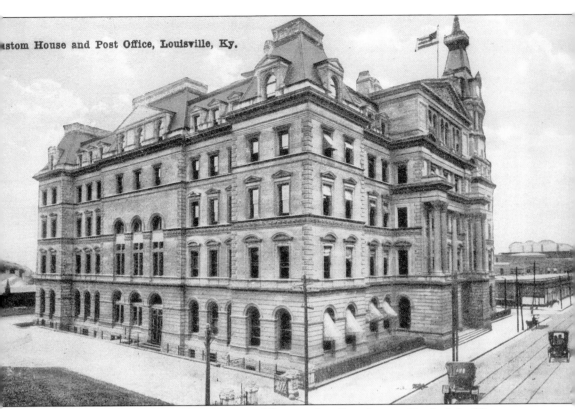

CUSTOMS HOUSE AND POST OFFICE. The massive Renaissance Revival building was completed in 1892 at the northeast corner of Fourth and Walnut Streets, presaging the movement of downtown commerce away from Main and Market Streets. After a new facility was opened on Broadway between Sixth and Seventh Streets in 1933, the old customs house and post office lay vacant for nearly 10 years, serving mainly as a home for pesky starlings. While some Louisvillians wanted to save the building and turn it into a cultural center, theater, or museum, many others considered it an eyesore, and it was demolished in 1943. More than 9 million pounds of iron and steel, 80,000 pounds of copper, 20,000 pounds of brass and bronze, and 20,000 pounds of lead were salvaged for use in World War II. A parking garage now occupies the site.

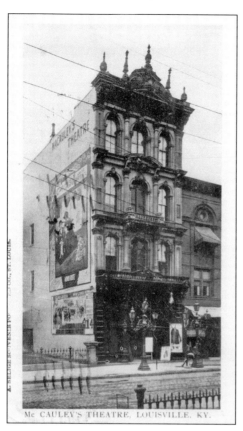

Mc CAULEY'S THEATRE, LOUISVILLE, KY.

MACAULEY'S THEATRE. Probably Louisville's most prestigious theater in the early 20th century, Macauley's opened in 1873 at 327 West Walnut Street and hosted the best of classical theater and later an occasional notable film such as *Birth of a Nation* (1915). The theater seated 1,500 and was known for its ornate interior. It was razed in 1925 to make room for an expansion of the Starks Building. (Courtesy of Louis Cohen.)

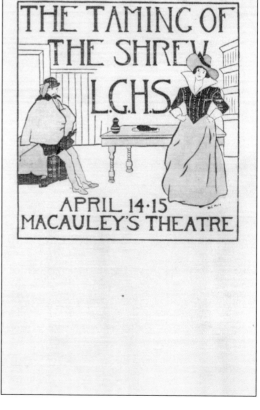

TAMING OF THE SHREW, **LOUISVILLE GIRLS' HIGH SCHOOL, 1916.** The Louisville Girls' High School was located at 506 West Hill Street at the time, but the drama students used Macauley's Theatre for their production of Shakespeare's *Taming of the Shrew* on April 14–15, 1916, and advertised the play by means of this postcard. (Courtesy of Louis Cohen.)

SEELBACH HOTEL. The opening of this elegant hotel at the southwest corner of Fourth and Walnut Streets in 1905 was arguably the key event that signified the new center of downtown Louisville. A roof garden and a European-style rathskeller were among the attractions that the Seelbach offered. Years of declining occupancy and increased maintenance costs forced closure of the Seelbach in 1975, but new ownership brought about its renovation and reopening in 1982.

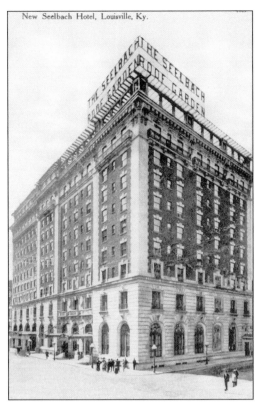

New Seelbach Hotel, Louisville, Ky.

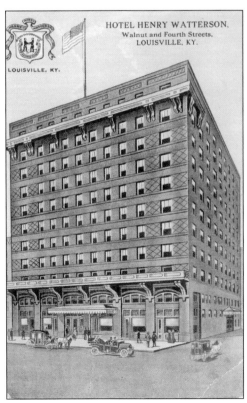

HOTEL HENRY WATTERSON,
Walnut and Fourth Streets,
LOUISVILLE, KY.

LOUISVILLE, KY.

WATTERSON HOTEL. Located at 415–421 West Walnut Street, the Watterson Hotel was named (with his permission) for the feisty editor of the Louisville *Courier-Journal*, Henry Watterson, and opened in 1912. An advertisement on the postcard notes that the hotel had 250 rooms that cost between $1.50 and $3 per night. The hotel closed in 1974 and was razed in 1981.

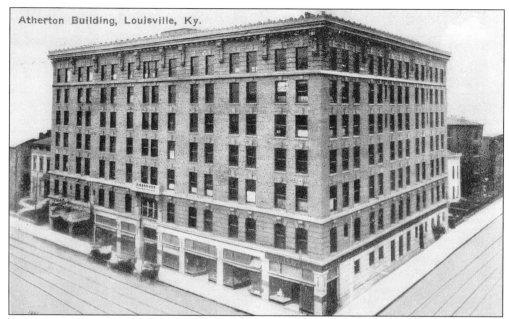

ATHERTON BUILDING. Located on the southwest corner of Fourth and Chestnut Streets, the Atherton Building was constructed in about 1906 as an office building and also the home of the Mary Anderson Theatre, which had a separate entrance at the south end of the building. (Some postcards refer to the building as the Mary Anderson Building.) Although the theater is gone and the facade has been altered beyond recognition, the building still stands.

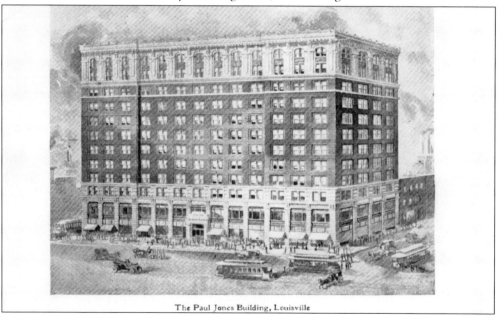

The Paul Jones Building, Louisville

PAUL JONES BUILDING. An important office building that marked the north end of the Fourth Street corridor, the Paul Jones building stood at 312 South Fourth Street between Jefferson and Green Streets. After 1917, it was known as the Marion E. Taylor Building, and because of its proximity to the courthouse and city hall, lawyers and insurance agents were its primary renters. Although somewhat altered, it remains an office building today.

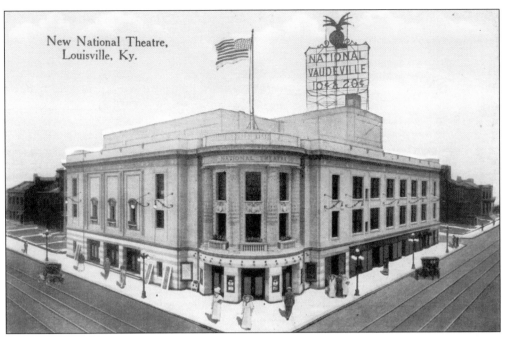

New National Theatre,
Louisville, Ky.

NATIONAL
VAUDEVILLE
10¢ & 20¢

NEW NATIONAL THEATER. This building was located at 500 West Walnut Street and opened in November 1913 as a vaudeville theater. After limited success as an independent theater, it was sold about 1915 to the B. F. Keith syndicate that controlled vaudeville, and it was renamed the B. F. Keith National Theatre. The theater was renovated to seat 2,800 people as part of the Keith circuit. By 1931, Keith was gone, and it resumed its original name. It was torn down in 1952 to make room for the Kentucky Hotel parking lot.

THE *BIRD OF PARADISE,* 1912. This postcard advertises a play, the *Bird of Paradise,* performed in November 1912 at the Shubert Masonic Theater. The play, by Richard Walton Tully, was a popular drama set in Hawaii. Its stars, Guy Bates Post, a well-known stage and screen actor, and Bessie Barriscale, a popular silent film actress, give evidence that the best theater in America at the time could be seen in Louisville. (Courtesy of Louis Cohen.)

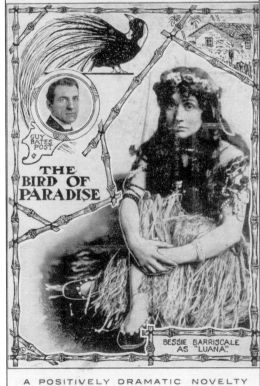

GUY
BATES
POST

THE
BIRD OF
PARADISE

BESSIE BARRISCALE
AS "LUANA"

A POSITIVELY DRAMATIC NOVELTY
Beautiful—Alluring—Entrancing
SHUBERT MASONIC ENTIRE WEEK BEGINNING
MONDAY NOVEMBER 25TH
MATINEES—WED. THURS. AND SAT.

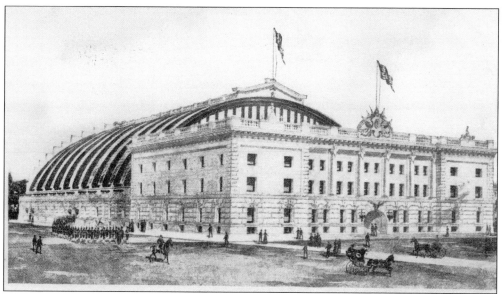

THE ARMORY. Brinton B. Davis designed this Beaux-Arts building located on West Walnut Street between Sixth and Center (now Armory) Streets. It opened in March 1906 and hosted events such as religious conferences and the Greater Louisville Exposition (1907). The armory played an important role as a refugee center during the 1937 flood. In 1963, it was renovated and renamed the Convention Center. In 1975, it became Louisville Gardens when the Kentucky International Convention Center was being constructed.

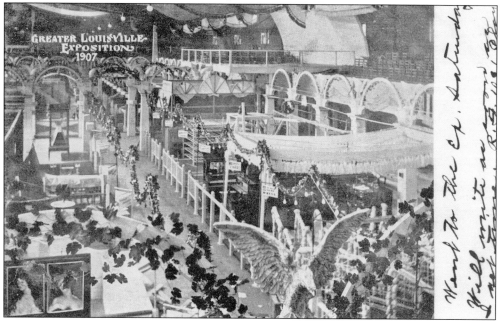

GREATER LOUISVILLE EXPOSITION, 1907. This exposition was held between March 18 and March 30 at the Armory and showcased products that were made in the Louisville area. Attendance for the 12-day event was 126,000, and the newspaper deemed the affair an artistic and financial success. It was one of the first major events to be held in the Armory. (Courtesy of Louis Cohen.)

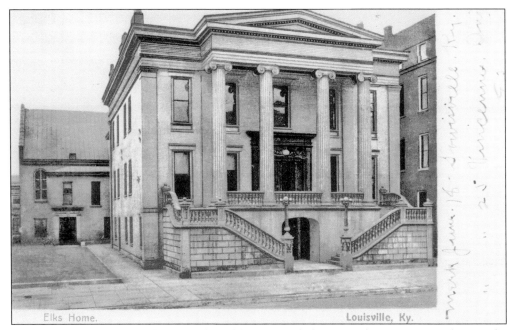

Elks Home. Louisville, Ky.

ELKS HOME. This Greek Revival building provided commodious accommodations for members of the popular fraternal lodge. It was located at 310 West Walnut Street and torn down to make way for an addition to Stewart's Department Store in the mid-1920s. By that time, a much larger Elks facility had been built at Third and Chestnut Streets.

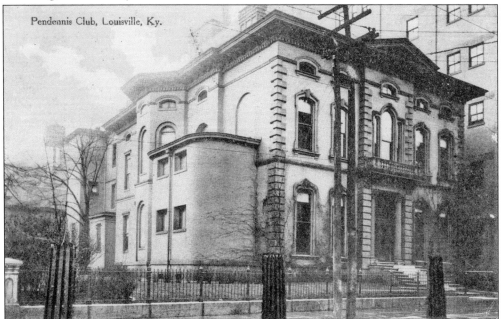

Pendennis Club, Louisville, Ky.

PENDENNIS CLUB. Located next door to the Elks Home at 322 West Walnut Street, the Pendennis Club, a private social club for white gentlemen of high social standing, opened at this location in 1885. This building, like the Elks Home, was razed when the Stewart's addition was built. In 1928, the Pendennis Club moved to a new building on Walnut Street near Second Street where it remains today, though with more liberalized membership standards.

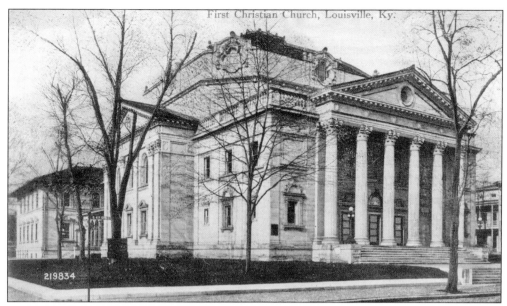

FIRST CHRISTIAN CHURCH. Built at the northeast corner of Fourth and Walnut Streets in 1864, this Greek Revival structure was originally named the Walnut Street Baptist Church. In 1876, it became the First Christian Church. In 1909, John Starks bought the site for $350,000 to erect the Starks Building. The First Christian Church moved to new quarters at Fourth and Breckinridge Streets. In 1977, the church became the Lampton Baptist Church.

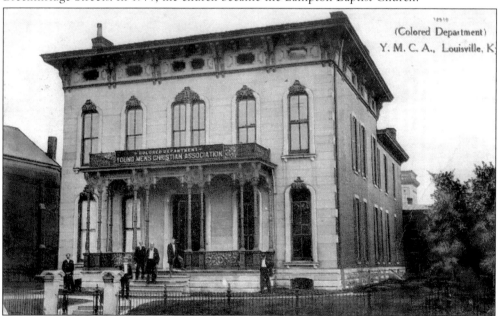

COLORED BRANCH, YMCA. First opened in 1883 on West Walnut Street, the African American YMCA moved to 914 West Chestnut Street where it served the African American community until 1932. Reopened in 1946 under the more discreet name of the Chestnut Street Branch, it remained a segregated facility until at least the 1960s. The Chestnut Street YMCA is still a part of the YMCA system, although it has moved down the block to 930 West Chestnut Street and shares a building with the Eureka Grand Temple. (Courtesy of Louis Cohen.)

JOHN C. LEWIS COMPANY. Typical of the many smaller business that developed in the area near Fourth and Walnut Streets, the John C. Lewis Company, a dry goods store, was located at 448–454 South Fourth Street from about 1909 until 1931. Evidently a victim of the Great Depression, the store closed and the building was vacant by 1933. But by 1935, Montgomery Ward Company, a national department store chain, had moved in. (Courtesy of Louis Cohen.)

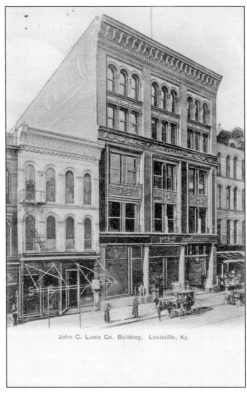

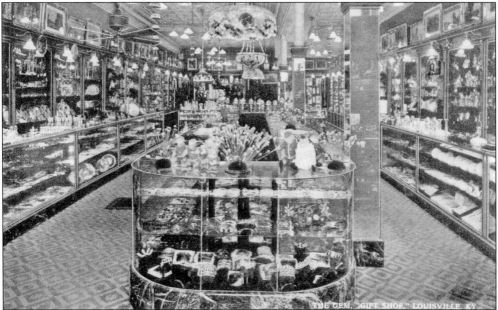

THE GEM GIFT SHOP, INTERIOR. This durable store was located at 420 South Fourth Street from about 1918 through the 1920s. In the 1930s, it moved to space in the Atherton Building at 604 South Fourth Street where it remained until 1966. The shop sold art goods and was managed for many years by the H. H. Newkirk Company. The postcard image is a rare look at the interior of a retail shop in the early 20th century. (Courtesy of Louis Cohen.)

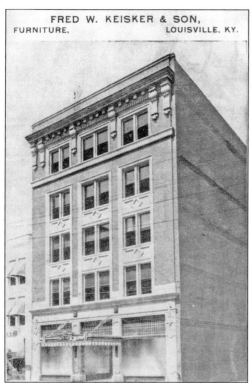

FRED W. KEISKER & SON,
FURNITURE, LOUISVILLE. KY.

FRED W. KEISKER AND SON. Another small business in the area around Fourth and Walnut Streets, Fred W. Keisker and his son, Charles H. Keisker, sold furniture, rugs, and mattresses at 313–315 West Walnut Street from the early 1920s until the mid-1930s. (Courtesy of Louis Cohen.)

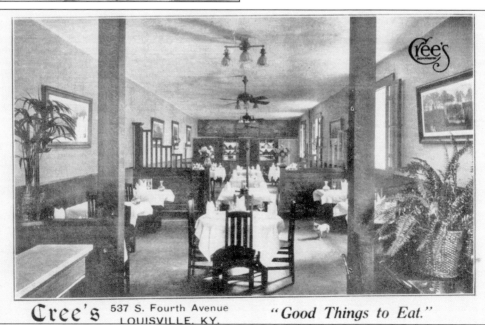

Cree's 537 S. Fourth Avenue
LOUISVILLE. KY. *"Good Things to Eat."*

CREE'S RESTAURANT. This popular eatery operated at different Fourth Street locations between 1918 and 1926. In 1918, it was located at 224 South Fourth Street with Archibald Cree as manager, and in 1922 at 537 South Fourth Street. By 1926, Cree's was gone, Archibald Cree had become a minister, and a Piggly Wiggly grocery store was at 537 South Fourth Street. (Courtesy of Louis Cohen.)

SOLDIER'S CLUB. This club existed from 1918 to 1919 at 619 South Fourth Street, evidently as a place where troops undergoing training at Camp Taylor could relax. In 1920, it moved to 305 West Chestnut Street but closed soon afterwards. The building was erected in 1912 for the Kentucky Electric Company and was known as the Electric Building. Besides the Soldiers' Club, the building had a variety of commercial occupants before an extensive renovation in the 1990s. It now houses Louisville's public radio stations.

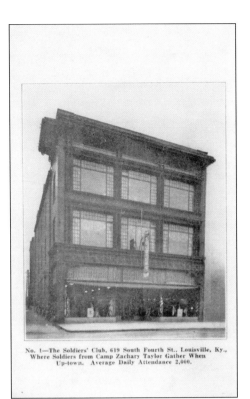

No. 1—The Soldiers' Club, 619 South Fourth St., Louisville, Ky., Where Soldiers from Camp Zachary Taylor Gather When Up-town. Average Daily Attendance 2,000.

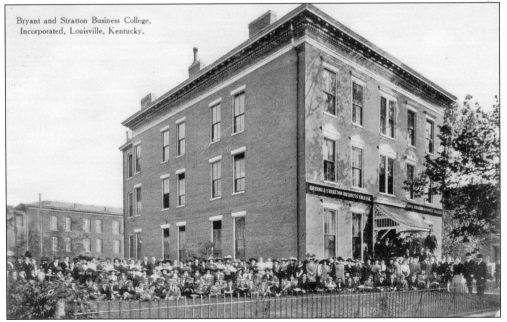

Bryant and Stratton Business College, Incorporated, Louisville, Kentucky.

BRYANT AND STRATTON BUSINESS COLLEGE. This national business college offered courses at various locations in Louisville during the early 20th century. It is likely that this postcard shows the college at its location on the southwest corner of Fifth and Walnut Streets, where it was in about 1916. Later it was located at 303 South Fifth Street and 333 Guthrie Street. It operated at the Guthrie Street location until the early 1970s.

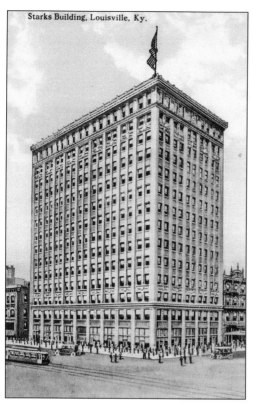

Starks Building, Louisville, Ky.

STARKS BUILDING. This 1913 office building was constructed on the site of the First Christian Church at Fourth and Walnut Streets. A blend of Chicago-style and Beaux-Arts architecture, the Starks Building helped make the intersection of Fourth and Walnut the center of downtown activity after 1915. A major addition in 1926 extended the building down Walnut Street and forced the razing of Macauley's Theatre and other historic buildings.

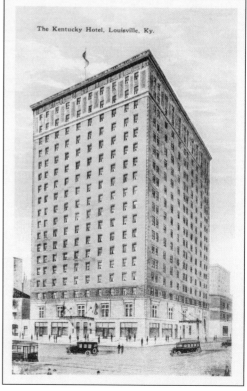

The Kentucky Hotel, Louisville, Ky.

KENTUCKY HOTEL. This 18-story hotel, located on the southeast corner of Fifth and Walnut Streets, opened in 1925 and was the last hotel to be built in downtown Louisville before World War II. In 1972, it was converted to apartments and renamed Kentucky Towers.

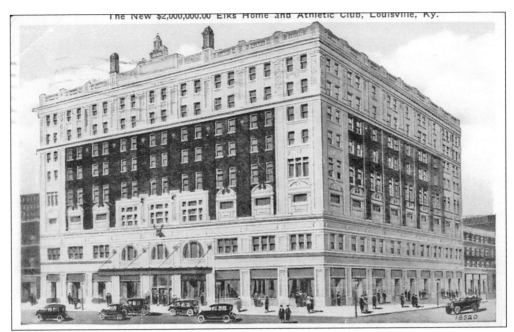

ELKS CLUB. This successor to the Elks Home opened in 1924. Located at Third and Chestnut Streets, the eight-story structure became the Henry Clay Hotel just four years later. Between 1964 and 1988, the YWCA was headquartered at the building. When the YWCA discontinued operations in Louisville, the building was vacant for a number of years and was threatened with demolition. In 2004, new owners undertook an extensive renovation that restored the building to its former elegance.

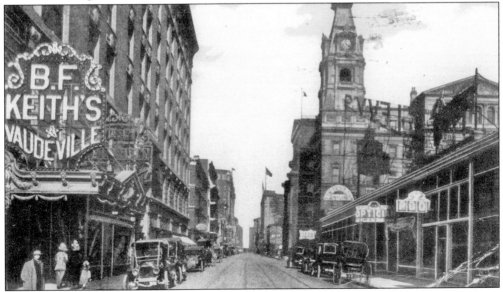

FOURTH STREET LOOKING NORTH. This 1916 picture shows Fourth Street looking north from a spot between Chestnut Street and Broadway. On the left is the former Mary Anderson Theatre, by this time taken over by the B. F. Keith vaudeville syndicate. On the right is the U.S. Customs House and Post Office. Farther down Fourth Street, the large building on the left side of the street is the Seelbach Hotel. (Courtesy of Louis Cohen.)

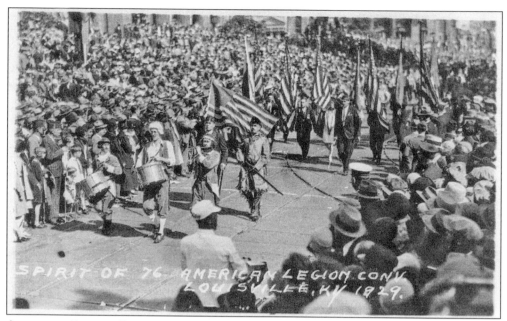

AMERICAN LEGION PARADE, 1929. The American Legion held its national convention in Louisville from September 30 to October 3, 1929. The *Courier-Journal* billed the event as the world's largest convention. A crowd of 300,000 watched the legionnaires parade on October 1, and newspaper accounts remarked that it took five hours for the entire parade to pass any point along the route. (Courtesy of Louis Cohen.)

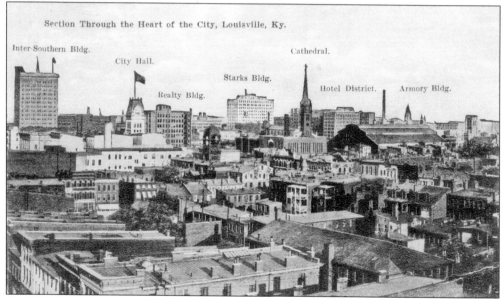

BIRD'S-EYE VIEW, 1922. Aerial views, or bird's eye-views, have been a popular postcard topic over the years. This view of downtown Louisville, which looks to the southeast from Eighth and Market Streets, shows the Inter-Southern Building at Fifth and Jefferson Streets and a number of buildings that contributed to moving the center of downtown activity to Fourth and Walnut Streets, including the Starks Building, the Cathedral of the Assumption, the hotel district (notably the Seelbach and the Watterson Hotels), and the Armory.

Three

DOWNTOWN
BROADWAY

In around 1900, Broadway, a very wide street running 7 miles from the entrance to Cave Hill Cemetery on the east to the Ohio River at the south end of Shawnee Park on the west, was home to many of Louisville's wealthiest citizens. A few nonresidential buildings interrupted the flow of homes, especially in the stretch of Broadway closest to downtown between Preston and Tenth Streets. The most prominent among them was Union Depot (or Station) for railroad passengers, which opened in 1891 and became the magnet that drew other business away from the river. Besides the train station, Broadway was beginning to develop as the center of Louisville's higher education district, particularly with respect to medicine and religion. As the following postcard images show, medical schools, hospitals, and seminaries were replacing homes along Broadway, and these would be followed by hotels, office buildings, and apartment buildings. By 1940 or so, most of the central Broadway residences had been razed, and those that remained had been converted to rooming houses or other uses.

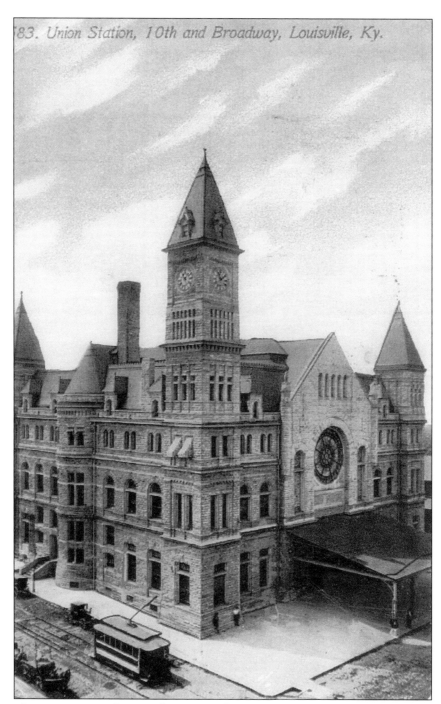

UNION STATION. Located at Tenth Street and Broadway, this Richardsonian Romanesque passenger train station opened in July 1891. It cost $400,000 and featured a large clock tower, a rose window 20 feet in diameter, and spacious public areas. The station survived a fire in 1905 and flooding in 1937 and served rail passengers until service was discontinued in 1976. The building then underwent a major renovation and became the headquarters for TARC (Transit Authority of River City), Louisville's public transit system, and remains so today.

L&N BUILDING. The Louisville and Nashville Railroad was the major line running in and out of Louisville, and this building, located just one block east of Union Depot, was its headquarters for many years after its completion in 1907. Following a major addition to the building in 1930, some 2,000 employees worked there. The building was sold to the Commonwealth of Kentucky in 1984 after the railroad merged with the Seaboard Coast Line, and it is now used for state offices.

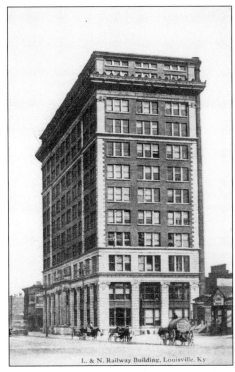

L. & N. Railway Building, Louisville. Ky.

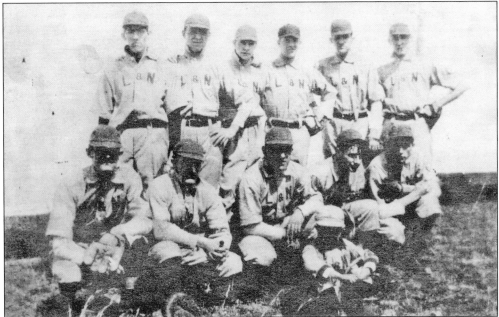

L&N BASEBALL TEAM. This real photograph postcard shows the L&N baseball team that played in the local Commercial League during the 1910s and 1920s. The team played against teams representing Belknap Hardware, Cumberland Telephone, L. Anderson, Mengel Woodworking, Starwood Products, and Stansaneo. Local amateur baseball was very popular at this time. In addition to the Commercial League, the city boasted several other leagues. (Courtesy of Louis Cohen.)

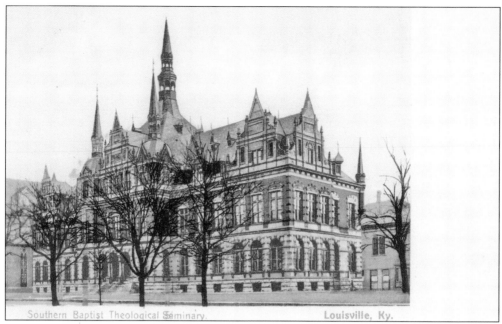

Southern Baptist Theological Seminary. Louisville, Ky.

SOUTHERN BAPTIST THEOLOGICAL SEMINARY. The Southern Baptist Convention moved its main seminary to Louisville in 1874 and erected this elaborate building at Fifth Street and Broadway in 1888. An addition, Norton Hall, opened in 1893. A new campus site along Lexington Road was purchased in 1921, and the first classes began there in 1926. The old seminary along Broadway was razed in the 1930s to make way for a Greyhound bus station.

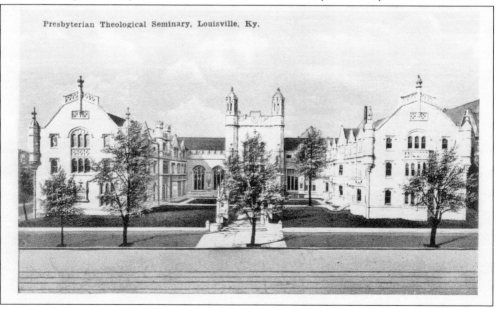

Presbyterian Theological Seminary, Louisville, Ky.

PRESBYTERIAN THEOLOGICAL SEMINARY. Founded as the Louisville Theological Seminary in 1893, this institution was renamed the Presbyterian Theological Seminary in 1901 after a merger with the Danville Theological Seminary, located in Danville, Kentucky. This building opened at First Street and Broadway in 1904. In 1963, the seminary moved to the Lexington Road area, and the old seminary became a part of Jefferson Community and Technical College in 1968.

40

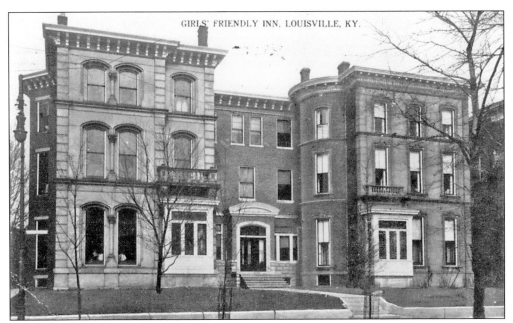

GIRLS' FRIENDLY INN, LOUISVILLE, KY.

GIRLS' FRIENDLY INN. As more women entered the workforce as secretaries, teachers, and nurses in the early 20th century, gender-specific residences were established for them. This rooming house was at 219 East Chestnut Street from about 1912 until 1950. By 1951, the home was gone, and a children's hospital was under construction at the site. (Courtesy of Louis Cohen.)

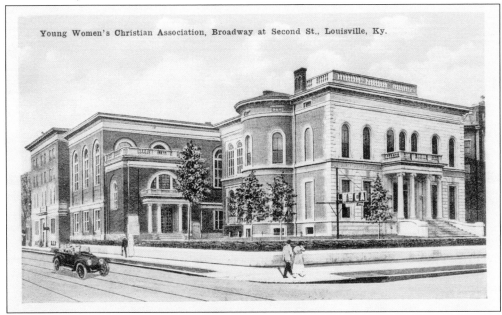

Young Women's Christian Association, Broadway at Second St., Louisville, Ky.

YWCA BUILDING. The YWCA began operating in Louisville in 1912, at first on the upper three floors of the Cohen Shoe Company building at 229 South Fourth Street. In 1914, the YWCA spent $300,000 to purchase the James C. Ford mansion, shown in this postcard image on Broadway at Second Street, and it remained there until 1964 when the organization moved to the former Henry Clay Hotel at Third and Chestnut Streets.

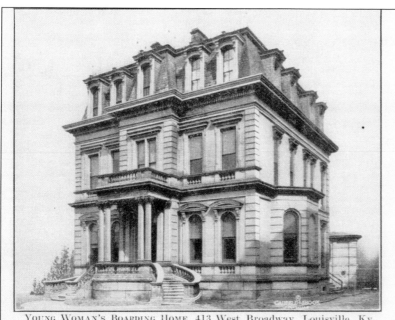

YOUNG WOMAN'S BOARDING HOME, 413 West Broadway, Louisville, Ky.

YOUNG WOMEN'S HOME, BROADWAY. Located at 413 West Broadway, this residence for women was more formally known as the Henri Barret Montfort Home. It was established sometime before 1903 and remained open to young women until the early 1950s. Eliza B. Long was the superintendent (or matron) from 1908 until at least 1942. It was razed to clear space for the Commonwealth Building. (Courtesy of Louis Cohen.)

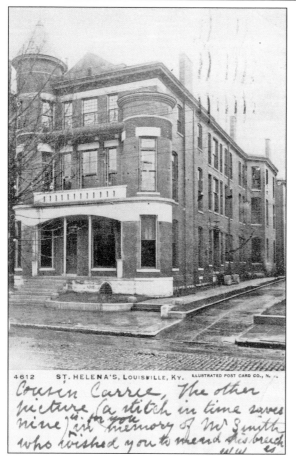

4612 ST. HELENA'S, LOUISVILLE, KY. ILLUSTRATED POST CARD CO., N.

ST. HELENA'S. St. Helena's was a Catholic commercial college for women, located at 623 South Fourth Street from 1907 until at least the 1920s. By the 1930s, the college was called St. Helena's Night School and had moved to 935 South Fourth Street, remaining there until 1959. (Courtesy of Louis Cohen.)

LOUISVILLE CONSERVATORY OF MUSIC.
This private music school was located at 214
West Broadway. Classes began in September
1915 in the old Dillingham mansion, shown
here. As enrollment grew, the conservatory
built a four-story structure at Brook and
Jacob Streets and moved there in 1927.
The onset of the Great Depression hit the
school hard, and it closed in February 1932.
The building was razed in the 1960s with
the construction of I-65. (Courtesy of
Louis Cohen.)

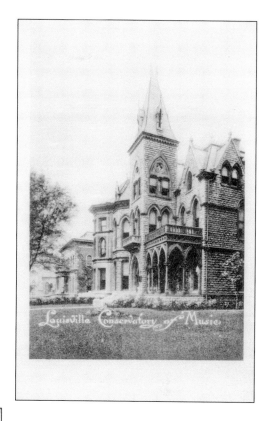

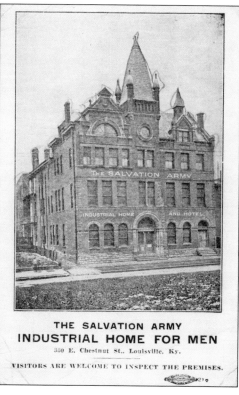

THE SALVATION ARMY
INDUSTRIAL HOME FOR MEN
350 E. Chestnut St., Louisville, Ky.

VISITORS ARE WELCOME TO INSPECT THE PREMISES.

SALVATION ARMY HOME FOR MEN. The
Salvation Army first established a presence
in Louisville in 1883. Soon after 1898,
this workingman's hotel was built at 330
East Chestnut Street. The Salvation Army
continued to manage the workingman's
home until the late 1950s, when the
building was torn down to make way for
the Towne House Apartments. (Courtesy of
Louis Cohen.)

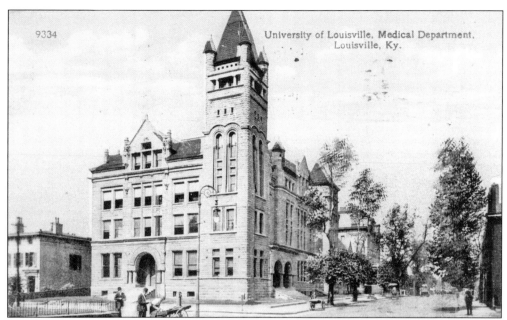

UNIVERSITY OF LOUISVILLE MEDICAL SCHOOL. Although the medical school of the University of Louisville was created in 1837, this building, located at First and Chestnut Streets, was built in 1893 for the Louisville Medical College, a private school. The Louisville Medical College was absorbed into the medical school in 1908, and this building remained in use until the 1960s. In 1977, the Jefferson County Medical Society Foundation acquired the building.

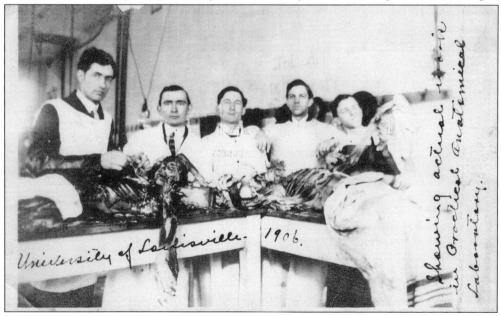

MEDICAL SCHOOL DISSECTION. The real photograph postcard, dated 1906, shows four students and an instructor standing over a cadaver they are dissecting as part of their Practical Anatomy course, a required course for all freshmen and sophomore students. Cadavers were usually indigent African Americans; an Anatomical Act regulated their acquisition. (Courtesy of Louis Cohen.)

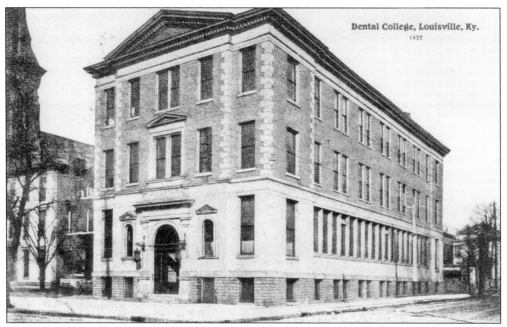

DENTAL COLLEGE. In 1868, the Louisville College of Dentistry was organized as a branch of a medical school known as the Hospital College of Medicine. In 1900, the college moved to this building at Brook Street and Broadway. After some years of affiliation with Central University of Kentucky, the dental school became part of the University of Louisville in 1918 and moved to new quarters in the downtown medical complex in 1970.

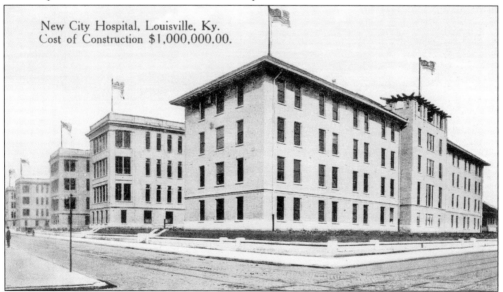

NEW CITY HOSPITAL. This new hospital was built on Chestnut Street between Brook and Preston Streets, close to the medical school, and opened in 1914. In 1943, it was renamed General Hospital, and in 1979, it was turned over to the University of Louisville and became known as University Hospital. Much of the original 1914 structure has been replaced by newer facilities, but the center block remains and serves as the Abell Administrative Building for the university's Health Sciences Center.

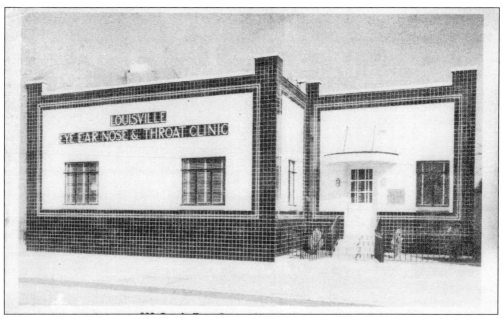

LOUISVILLE EYE, EAR, NOSE, AND THROAT CLINIC. Typical of the smaller doctor's offices and clinics that are found near hospitals, the Louisville Eye, Ear, Nose, and Throat Clinic was built at 629 South First Street in 1938 and staffed by J. R. Hester, J. E. Craddock, and Charles Roser Jr. It remained at that location until the mid-1960s, when it was torn down to make way for the construction of I-65.

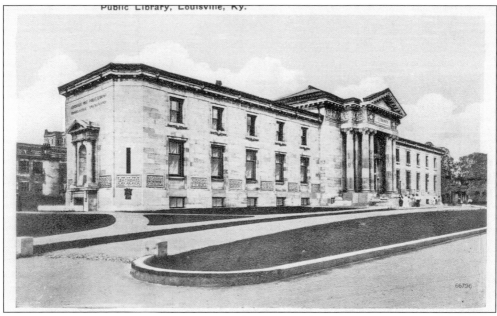

LOUISVILLE FREE PUBLIC LIBRARY. One of hundreds of public libraries funded by Andrew Carnegie in the early 20th century, the Louisville Free Public Library on York Street between Third and Fourth Streets opened in 1908. A large addition to the north side of the library, in the then-popular Brutalism style, opened in 1969 and satisfied a pressing need for more space at the cost of the building's architectural integrity.

46

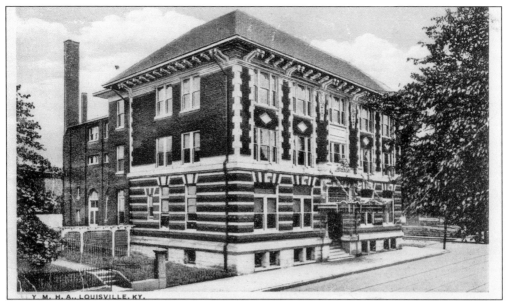

YOUNG MEN'S HEBREW ASSOCIATION (YMHA). This building, constructed in 1915 at Second and Jacob Streets, was just two blocks from the downtown YMCA. It provided athletic facilities and classes for both men and women, and its members were active in local charity drives, providing hospitality for Jewish troops in World Wars I and II, and sponsoring English classes for immigrants. Eventually, its name was changed to the Jewish Community Center, and the building was replaced by a larger facility on Dutchman's Lane in 1955.

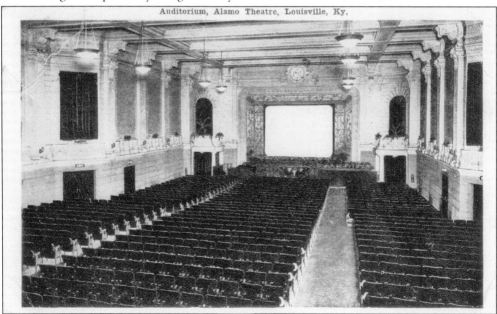

INTERIOR, ALAMO THEATER. Another force moving the center of downtown activity to the Broadway area was the development of a theater district. Typical of the new theaters in this area was the Alamo, whose interior with a seating capacity of 1,100 is shown here. Designed by Joseph D. Baldez, it opened in November 1914 at 444 South Fourth Street. It was razed in 1940 to make way for a new Woolworth's store.

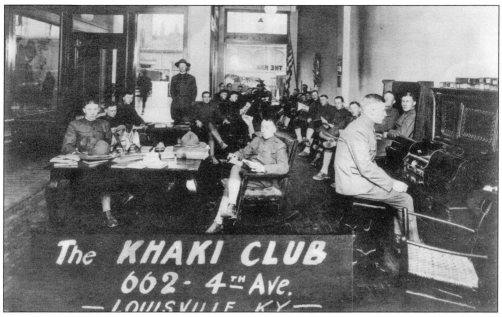

ALLEN E. REID'S

NEW HOME

For the Distribution of

Overland Gas Cars and Waverly Electrics

Equipped for

STORING, ELECTRIC CHARGING, and SERVICE

726-728 South Fourth Street :: LOUISVILLE, KY.

KHAKI CLUB. This short-lived nightspot for World War I personnel was located in the Ha-Wi-An Gardens dance hall, built by J. Graham Brown at the northwest corner of Fourth Street and Broadway. It opened in October 1917 and was closed by 1920. The Ha-Wi-An Gardens was destroyed by a fire in October 1923 and replaced by the Martin Brown Building, a four-story office building. (Courtesy of Louis Cohen.)

ALLEN E. REID AUTO AND ELECTRIC. Located at 726–728 South Fourth Street, this building housed Allen Reid's distributorship for Overland Gas Cars and Waverley Electrics for a short time around 1914. The advertising postcard notes that his business was equipped for storage, electrical charging, and service for automobiles. Although Reid was gone by 1918, the building continued to be used for the same purpose until the 1930s. (Courtesy of Louis Cohen.)

BROWN HOTEL. Built by J. Graham Brown in 1923 at the northeast corner of Fourth Street and Broadway, this elegant 15-story hotel included a street-level restaurant and shops. Brown was a very successful commercial real estate developer, horse breeder, and philanthropist. After his death in 1969, the hotel closed and was used by the local school system for administrative purposes. In the mid-1980s, the hotel reopened after a major renovation.

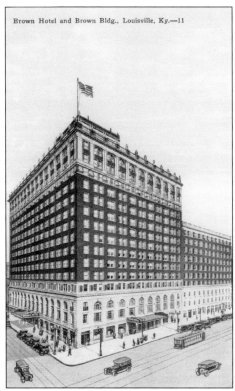

Brown Hotel and Brown Bldg., Louisville, Ky.—11

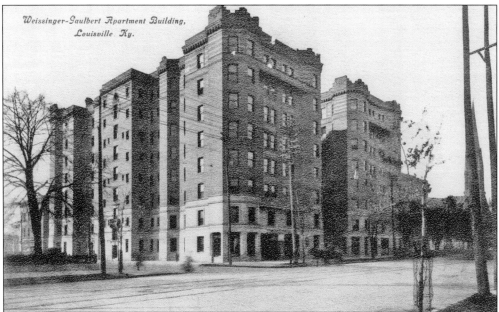

Weissinger-Gaulbert Apartment Building, Louisville, Ky.

WEISSINGER-GAULBERT APARTMENT BUILDING. Located just across Broadway from the Brown Hotel, the Weissinger-Gaulbert Apartment Building was the second apartment block to be built in the city and helped trigger an apartment boom in the early 20th century. The nine-story building, which dates to 1903 and still stands today, led to later substantial apartments in Old Louisville such as the Puritan (1913) and the Mayflower (1925).

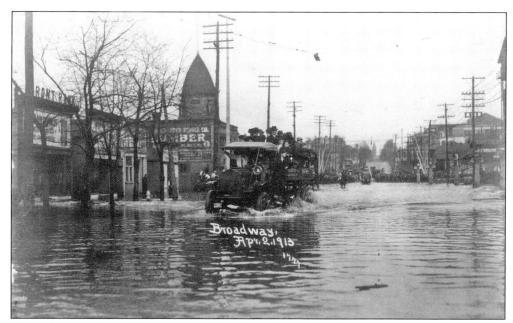

1913 FLOOD, EAST BROADWAY. The Ohio River flood of April 1913, described by contemporaries as the worst ever, was accompanied by winds of up to 48 miles per hour. This real photograph postcard looks east down Broadway from Campbell Street. The only legible sign is for the Alfred Struck Lumber Company, which was located at the corner of Chestnut and Garden Streets a block north of Broadway. (Courtesy of Louis Cohen.)

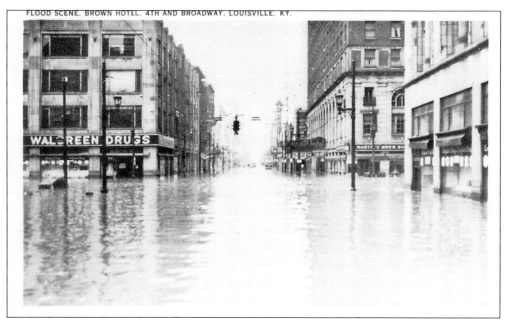

1937 FLOOD, FOURTH STREET AND BROADWAY. Although the 1937 flood, which really was the worst ever, spared a part of downtown north of Chestnut Street, Broadway was not so fortunate. This postcard shows the intersection at Fourth Street and Broadway with the Brown Hotel on the right across the street.

Four

OLD LOUISVILLE

Old Louisville is the name given to a residential area immediately south of downtown Louisville whose development was spurred by the Southern Exposition of 1883–1887. It runs from York Street on the north to the Belknap campus of the University of Louisville on the south, and from Floyd Street on the east to an irregular boundary roughly at Sixth Street on the west. After the close of the exposition, there was what amounted to a building boom over the next two decades. Hundreds of large Victorian homes were built with the most elegant rising along Second, Third, and Fourth Streets and in the exclusive neighborhood of St. James and Belgravia Courts. Churches, schools, and the occasional retail businesses were also built in this area. The district is much the same today, although many of the homes have been turned into apartment houses or have come to serve other purposes—for example, the Filson Historical Society, a regional history archives and library, is based in an Old Louisville mansion.

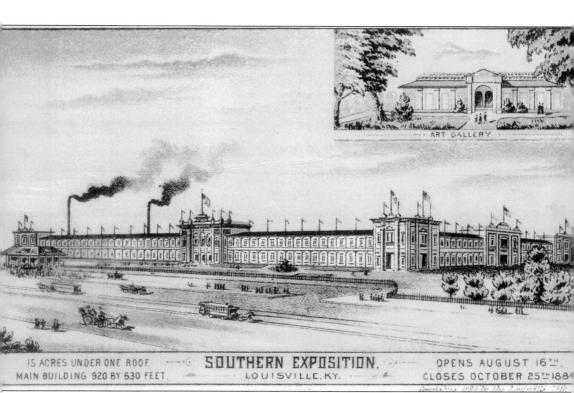

ART GALLERY

15 ACRES UNDER ONE ROOF. SOUTHERN EXPOSITION, OPENS AUGUST 16TH,
MAIN BUILDING 920 BY 630 FEET. LOUISVILLE, KY. CLOSES OCTOBER 25TH 1884

SOUTHERN EXPOSITION. This small world's fair that opened in August 1883 was meant to promote Louisville's developing industrial economy and its ability to serve as a transportation link between the North and the South. The exposition was held in a large temporary structure built on 40 acres of vacant land about 2 miles south of downtown Louisville, now occupied by Central Park and St. James and Belgravia Courts. The main building covered 13 acres and was the largest wooden building in the United States at that time. In 1883, more than 600,000 visitors came to the exposition in the three months that it was open, and that success led managers to repeat the exposition for each of the next four years. The building hosted a Floral Exhibition in 1888 and was torn down the following year to allow for residential development on and around the site.

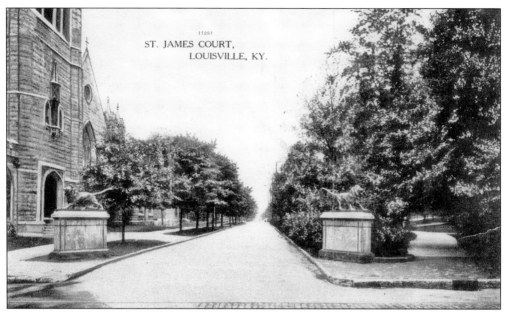

ST. JAMES COURT, ENTRANCE. This elite neighborhood was developed after the Southern Exposition in the style of a quiet English community. Construction of homes began in early 1890 along a new street, St. James Court, and a pedestrian-only thoroughfare, Belgravia Court. This postcard view looks west down Victoria Place, the name of that part of Magnolia Avenue adjacent to St. James Court between 1895 and 1913. The view looks much the same today, although the lions guarding the court have been removed.

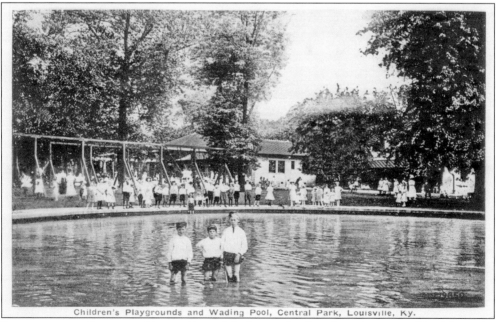

PLAYGROUND, CENTRAL PARK. Central Park was developed on 17 acres of land from the Alfred DuPont family estate, and it is located on the site of the Southern Exposition. The playground and pool, situated to the west of the colonnade, were very popular in the 1920s. They have since been transformed into a paved space with a fountain in the center.

53

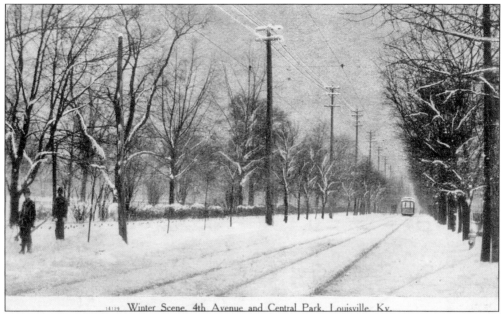

WINTER SCENE ON FOURTH STREET. Significant snowfalls do not come often to Louisville, but when they do, they are nowhere as beautiful as along the tree-lined streets in Old Louisville. This view shows Fourth Street along the east side of Central Park.

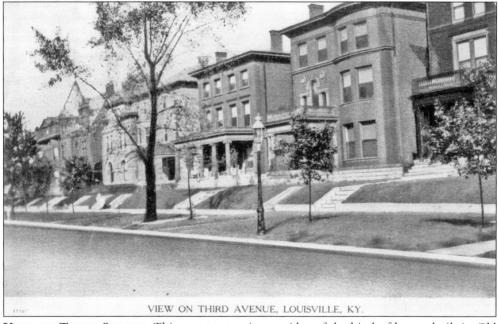

VIEW ON THIRD STREET. This streetscape gives an idea of the kind of homes built in Old Louisville between 1890 and 1920. This view looks north on Third Street near Lee Street. The two houses in the foreground appear to be 1513 and 1517 South Third Street, and they are still there with only minor alterations.

FIRST UNITARIAN CHURCH. Located on the southeast corner of Fourth and York Streets, this neo-Gothic church dates from 1870 and anchors the north end of Old Louisville. H. P. Bradshaw designed the church with an open-timbered ceiling and heavy dark woodwork. A fire in December 1985 gutted the interior of the church and destroyed the steeple, but the congregation rebuilt, using the existing stone walls, and the building reopened in 1989.

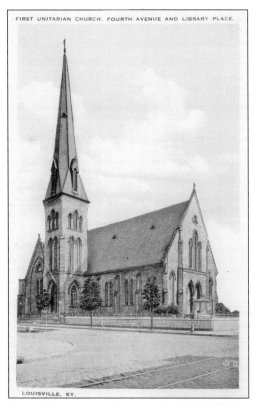

FIRST UNITARIAN CHURCH, FOURTH AVENUE AND LIBRARY PLACE.

LOUISVILLE, KY.

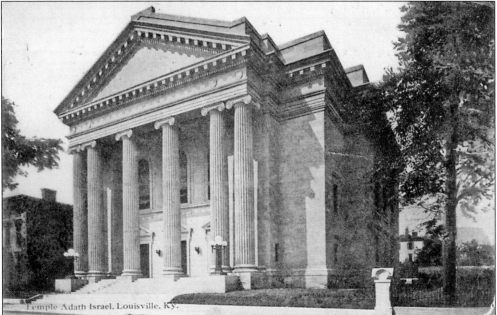

Temple Adath Israel, Louisville, Ky.

TEMPLE ADATH ISRAEL. This Jewish temple was formed in 1849 on Fourth Street near Walnut Street and moved in 1908 to this Greek Revival structure on Third Street south of York Street. The congregation relocated to a new temple on Brownsboro Road in 1978, and this building was sold to the Greater Bethel Temple Apostolic Church that still meets there.

55

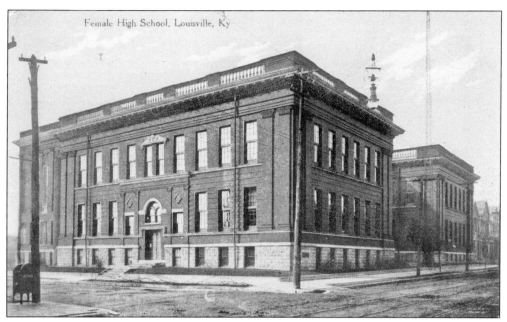

FEMALE HIGH SCHOOL. In 1899, the Female (or Girls') High School moved to the building shown here at Fifth and Hill Streets and remained there until 1935. The building then became the school district headquarters until it was razed in the 1970s. After 1935, the female students were located at Halleck Hall, at Second and Lee Streets, until that school was merged with Manual High School in 1950.

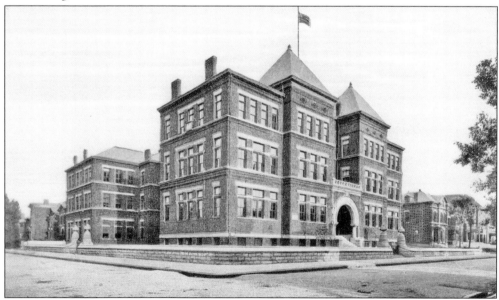

MANUAL TRAINING SCHOOL. Located at the southeast corner of Brook and Oak Streets on land donated by Alfred DuPont, this school was built in 1892. Its name was changed to DuPont Manual High School when it moved to Second and Lee Streets and merged with the Girls' High School. The building shown here then became Manly Junior High, which was closed and partially razed in 1978. The remaining part of the structure has been converted into condominiums.

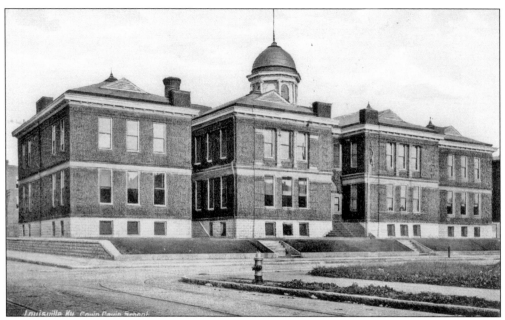

CAVIN COVIN SCHOOL. Not all information one reads on postcards is correct. This school is actually the Gavin H. Cochran School, located at 1700 South Second Street. An elementary school, it was built about 1900 and named for a former school board president. In 1991, it became an annex to the Youth Performing Arts School, a purpose it still serves today.

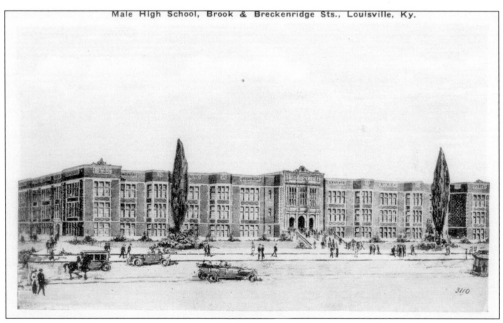

MALE HIGH SCHOOL. This most storied of Louisville public high schools was initially established at Ninth and Chestnut Streets in 1856. It moved to First and Chestnut Streets in 1898, and then to the building shown here at Brook and Breckinridge Streets in 1915. Male High School became coeducational in 1952 and remained at this location until 1991, when it moved to the old Durrett High School on South Preston Street.

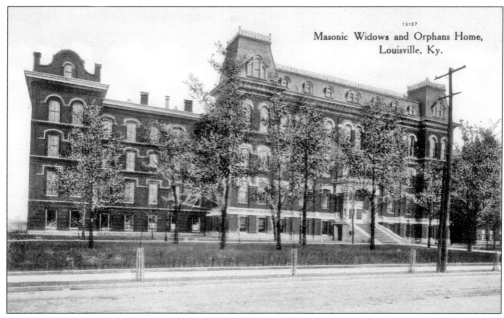

MASONIC WIDOWS HOME. The Kentucky Legislature chartered a Masonic Widows and Orphans Home in 1867, the first such home in North America. This building opened in the early 1870s, although it was not completed until 1881. It was located near Second and Lee Streets and housed 305 people. In the late 1920s, the home moved to a spacious new site at 3701 Frankfort Avenue near the town of St. Matthews, 5 miles east of downtown.

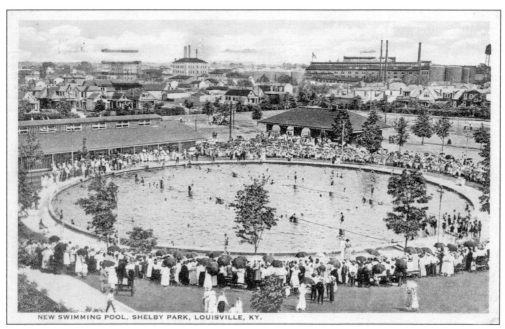

SHELBY PARK POOL. Shelby Park was a small neighborhood park located on the south side of Oak Street near Hancock Street just a few blocks east of Old Louisville. The park was laid out in 1908 as part of the neighborhood of the same name, and the pool was added about 1917. It has since been replaced with a typical rectangular park pool.

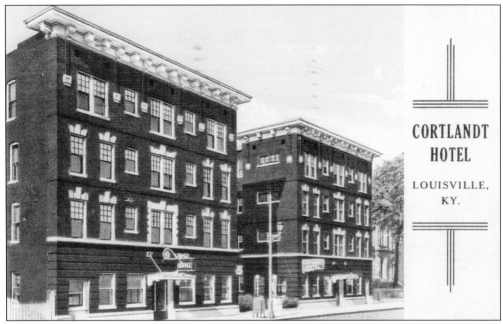

CORTLANDT HOTEL. Originally built in the early 1920s as an apartment house at 942–948 South Fourth Street, the Cortlandt became a hotel sometime before 1938. A restaurant and a dry cleaning establishment were also on the site. In the late 1940s, the north part of the hotel became the Christian Church Women's Home, but the south section at 948 South Fourth Street continued to operate as a hotel until 1956, when the entire building was taken over by the women's home. The structure was demolished in the late 1970s.

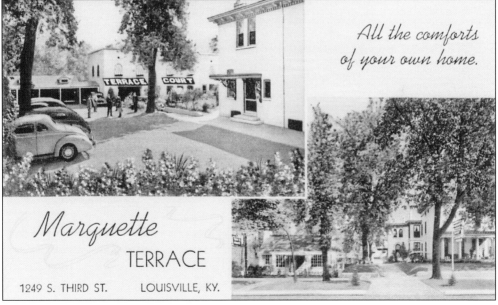

MARQUETTE TERRACE HOTEL. Built around 1936 at 1249 South Third Street as a house featuring furnished rooms for rent, the Marquette Terrace became a hotel in the 1940s. It was torn down in the early 1970s to make room for the Hillebrand House, a privately operated residence for senior citizens.

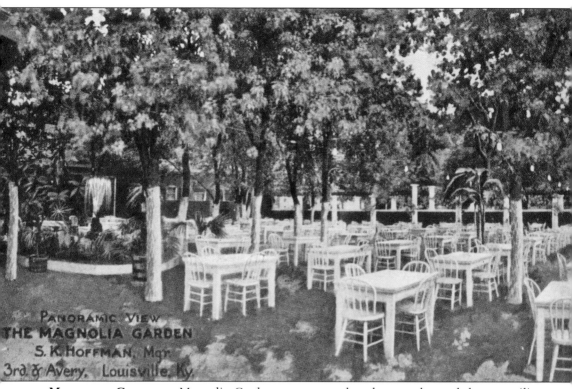

MAGNOLIA GARDENS. Magnolia Gardens was an outdoor beer garden and dance pavilion that opened about 1913 at the northwest corner of Third and Avery Streets, not far from the present Belknap campus of the University of Louisville. It became Rainbow Gardens in 1924,

which advertised that it was "Louisville's Dance Palace, with Dick Quinlan's Golden Derby Orchestra. Best Dance Floor in the South, Best Orchestra this Side of New York." However, by 1930, Rainbow Gardens was gone.

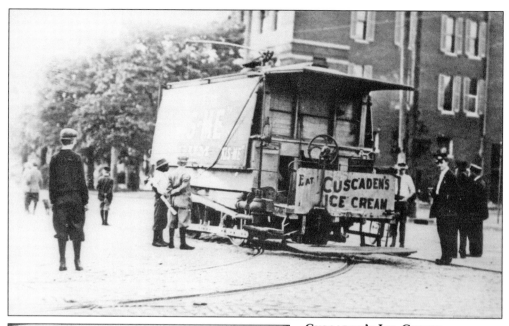

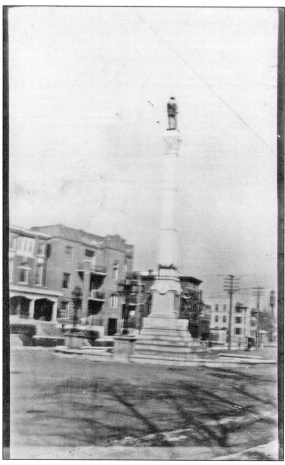

CUSCADEN'S ICE CREAM.
Cuscaden's sold locally produced ice cream and was owned by George W. Cuscaden Sr. As the postcard image shows, the ice cream could be purchased from wagons on street corners in Old Louisville and other parts of town. For a time, Cuscaden's also had retail outlets in the city and advertised under the slogan, "Cuscaden is the Ice Cream Man." In 1931, Cuscaden's merged with Furnas Ice Cream Company.

CONFEDERATE MONUMENT.
Louisville's monument to Confederate war dead is located just south of Third Street and Brandeis Avenue. The monument was sponsored by the Kentucky Women's Confederate Monument Association and erected in 1895. Michael Muldoon, a Louisvillian, was given the contract. This real photograph postcard view shows the monument from the rear; the buildings in the background have been razed to make room for commercial development. (Courtesy of Louis Cohen.)

Five

WEST OF DOWNTOWN

This area can be roughly defined as stretching from Tenth Street on the west edge of downtown to the Ohio River on the west and from the river on the north to Algonquin Parkway on the south, although there are no clear lines of demarcation. In Louisville's history, the vicinity has included the neighborhoods of Parkland, Shawnee, Russell, California, and several others including Portland, which was important during the 19th century as a maritime community below the Falls of the Ohio and now a Louisville neighborhood. This part of the city boasted a sizable manufacturing area, including, for example, Rubbertown, an industrial complex that became the world's largest producer of synthetic rubber during World War II. Much of the population of this area consisted of the people who worked in the factories. Finally, beginning in the first decade of the 20th century, Shawnee Park, the state fairgrounds, and two former popular amusement parks brought many people from all parts of the city into this area for fun and entertainment.

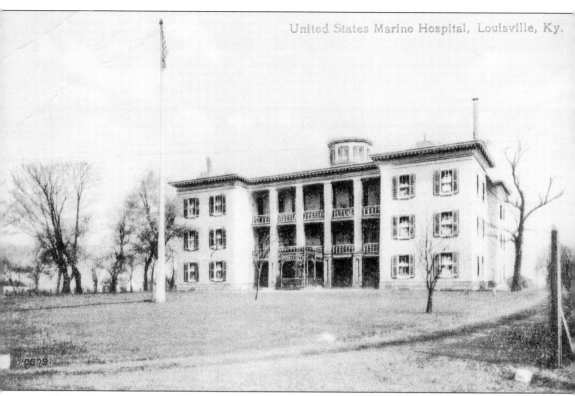

United States Marine Hospital, Louisville, Ky.

U.S. MARINE HOSPITAL. The Marine Hospital was evidence of Louisville's importance as a river-based commercial and transport center. The hospital pictured here was built between 1845 and 1852 near Twenty-second Street and Northwestern Parkway. In the 1930s, a new hospital was constructed just behind the Marine Hospital, and the old structure was abandoned. In 1997, the hospital was placed on the National Register of Historic Places, and soon thereafter extensive exterior and interior renovation began. (Courtesy of Rick Bell.)

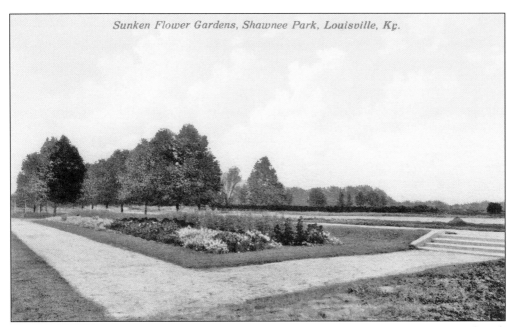

Sunken Flower Gardens, Shawnee Park, Louisville, Ky.

SUNKEN GARDENS, SHAWNEE PARK. Shawnee Park, an Olmsted Brothers original park design, opened in 1892 at a site along the Ohio River at the end of Market Street. It became popular when streetcar lines reached it three years later. Part of what was known as "Louisville's Emerald Necklace," Shawnee Park remains popular for sports events and family gatherings.

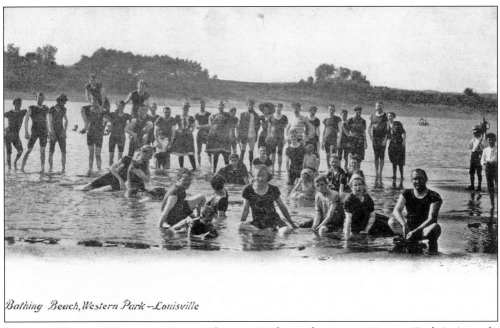

Bathing Beach, Western Park—Louisville

BATHING BEACH, WESTERN PARK. Shawnee Park was known as Western Park in its early days, and its location on the river afforded people an opportunity to swim at a time when the river was clean enough to do so.

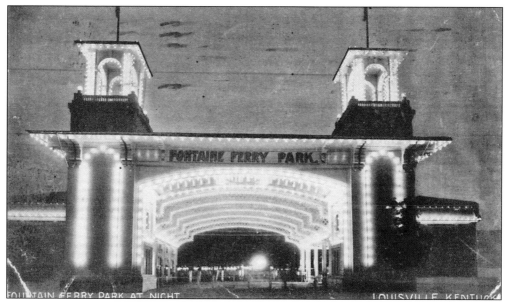

FONTAINE FERRY PARK AT NIGHT. Fontaine Ferry Park was for many years a very popular amusement park adjacent to Shawnee Park along the Ohio River. In 1903, John Miller, an amusement park architect, was commissioned to design this park that opened in 1905. The park was named for Capt. Aaron Fontaine, on whose estate (which contained a ferry landing) it was built. Many pronounced Fontaine as fountain, and it was frequently spelled that way as well.

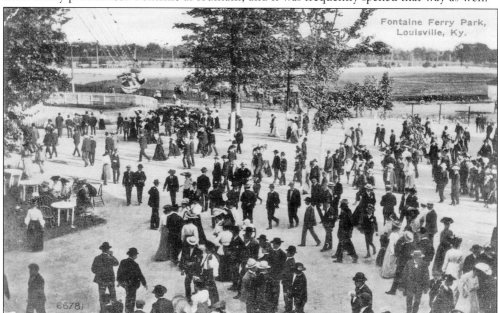

FONTAINE FERRY PARK PATRONS. Visitors came to the park to enjoy some of the more than 50 rides, to have a picnic, or to swim in a large pool. At night, they danced at Gypsy Village, an outdoor dance pavilion. Until 1964, the park was segregated, and when integration came racial tensions led to an ugly incident in 1969. After that incident, the park closed. It was reopened as Ghost Town on the River in 1972 and resurrected again as River Glen Park in 1975, but closed permanently in 1976.

FONTAINE FERRY PARK VISITORS' PHOTOGRAPH. One of the most popular attractions at Fontaine Ferry Park was the photograph booth, where visitors could have their picture taken and printed on postcard stock, ready to mail to their friends and family.

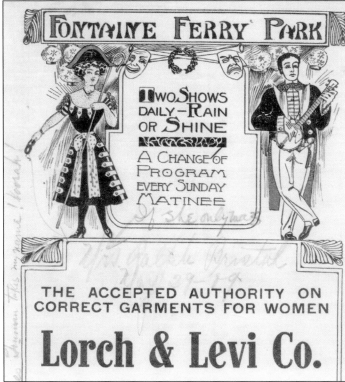

FONTAINE FERRY PARK ADVERTISEMENT. This advertisement, which is undated but appears to be from around 1915, alerts readers that the park presents two shows daily and changes the program every Sunday matinee. On the back of the advertisement, a program lists the following performances: the orchestra, conducted by Turner W. Gregg; the Clipper Quartet, comedians and singers; the Blessings, billed as "Europe's Greatest Equilibrists;" and Burt and Lottie Walton, acrobatic dancers.

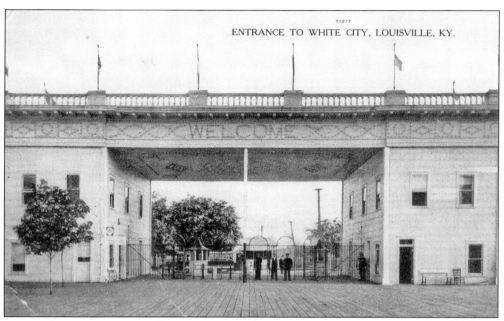

WHITE CITY, ENTRANCE. This amusement park was located on the Ohio River at Greenwood Avenue, south of Chickasaw Park, which was south of Shawnee Park. White City opened April 27, 1907, billing itself as the "Coney Island of the South." Its impressively ornate white buildings were lit by 250,000 electric lights, and its many attractions included canals of Venice-like boats, a water ride, a scenic railway, and a vaudeville stage.

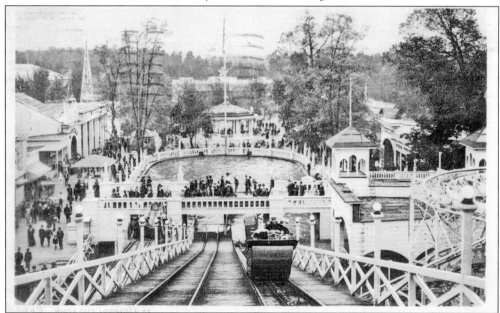

WHITE CITY, CHUTES RIDE. This postcard shows the popular Chutes ride, in which patrons would slide down a ramp in small boat-like vessels and splash into a pool below, usually drenching themselves. Rides such as this one would have made White City a strong competitor with Fontaine Ferry Park, but a major fire in 1910 damaged the park and ruined its future. The park closed after the 1912 season.

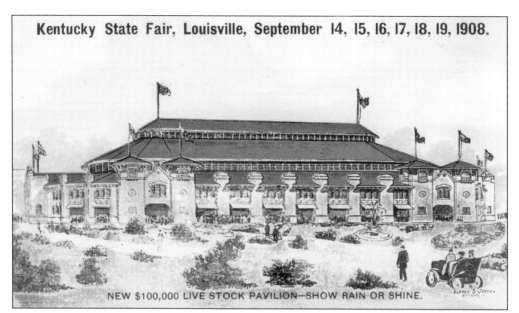

Kentucky State Fair, Louisville, September 14, 15, 16, 17, 18, 19, 1908.

NEW $100,000 LIVE STOCK PAVILION—SHOW RAIN OR SHINE.

STATE FAIR, MAIN BUILDING. The Kentucky Legislature authorized a state fair in 1902, and for the first few years, it was held at Churchill Downs, in Owensboro, or in Lexington. A permanent site was chosen in 1907, on 150 acres of land located on the south side of Cecil Avenue west of Thirty-eighth Street. The state fair was held there from 1908 until 1955. The building shown here, referred to as the main building, was the Livestock Pavilion.

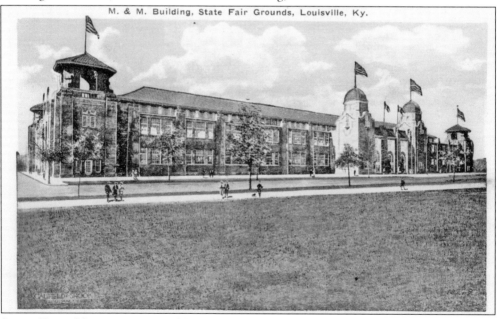

M. & M. Building, State Fair Grounds, Louisville, Ky.

STATE FAIR, MERCHANTS AND MANUFACTURERS BUILDING. This building, also called the M&M Building, opened on the state fairgrounds in 1921, billing itself as larger than Madison Square Garden. The local architectural firm Joseph and Joseph designed the building in a Spanish Renaissance style, and it contained exhibits of finished products and manufactured goods. The structure, now owned by the Whayne Supply Company, is still standing with its brick exterior painted white.

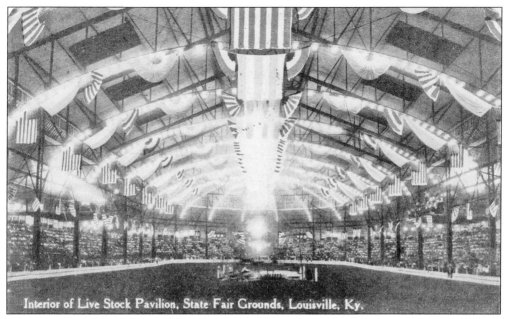

Interior of Live Stock Pavilion, State Fair Grounds, Louisville, Ky.

STATE FAIR, LIVESTOCK PAVILION. This interior view of the Livestock Pavilion gives some idea of its size. The pavilion was billed as the largest in the state at the time it opened in 1908. The stands held 3,700 spectators, and the electric lights shown in the postcard image were installed in 1909, allowing for evening events.

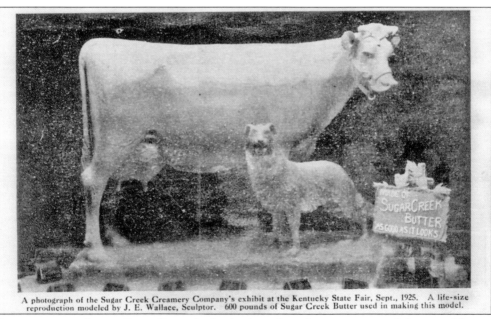

A photograph of the Sugar Creek Creamery Company's exhibit at the Kentucky State Fair, Sept., 1925. A life-size reproduction modeled by J. E. Wallace, Sculptor. 600 pounds of Sugar Creek Butter used in making this model.

LIVESTOCK AT STATE FAIR. From the beginning, the primary purpose of the state fair was to put the best Kentucky farm products on display, including livestock and planted crops. The early state fairs had sections for horses, mules, cattle and dairy cows, sheep, goats, and poultry. This postcard advertises the Sugar Creek Creamery Company's presence at the 1925 state fair with a cow and dog sculpted out of 400 pounds of Sugar Creek butter.

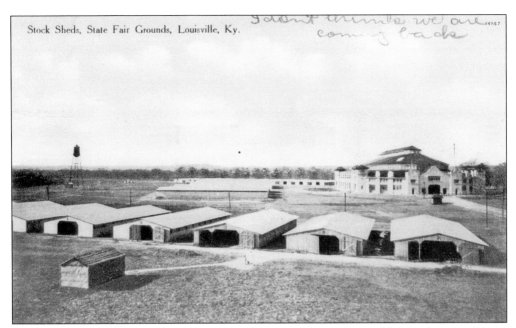

Stock Sheds, State Fair Grounds, Louisville, Ky.

I don't think we are coming back

STATE FAIR, LIVESTOCK SHEDS. Buildings for livestock were erected for the first state fair on Cecil Avenue in 1908, and more were added as the fair grew. Many of the earliest buildings were temporary sheds, but gradually, permanent barns were constructed. This postcard, postmarked in 1910, shows what appear to be fairly substantial stock sheds.

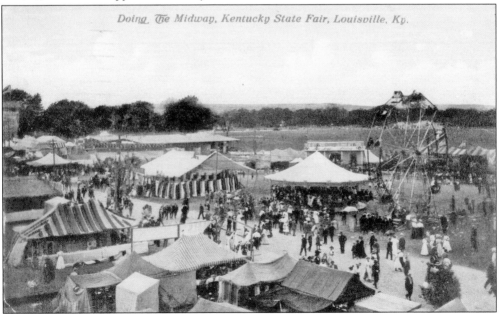

Doing The Midway, Kentucky State Fair, Louisville, Ky.

STATE FAIR, MIDWAY. The Kentucky state fair midway, with concessions, rides, and other forms of entertainment, was sometimes called the "Pike," borrowed from the midway at the 1904 Louisiana Purchase International Exposition held in St. Louis. Among the attractions on the midway in the early years were a minimalist Ferris wheel, visible in this 1911 postcard, and other portable rides and sideshow features, often exploiting so-called freaks and various games of chance.

71

Mengel's Mahogany Sawmill and Log Yard at Louisville, Ky., showing the Lidgerwood Cableway in operation, also the Dimension Mill and Dry Kilns and a corner of the Loading Sheds.

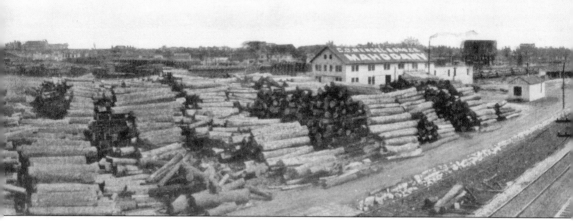

MENGEL MAHOGANY COMPANY. A major Louisville industry from 1877 to 1960, the C. C. Mengel Company manufactured tobacco boxes, whiskey barrels, and other hardwood products. In the 1890s, Mengel opened a plant covering 10 acres on Kentucky Street between Tenth and Twelfth Streets, shown in this double-wide postcard. At the time, the plant employed 600 workers. In the 1920s, at another location, the Mengel Company made wooden automobile bodies, and during the 1937 flood, the company donated hundreds of whiskey barrels to make

the pontoon bridge that allowed many stranded people to escape to dry land in the Highlands. During World War II, the company played an important role in the manufacture of the C-76 Caravan, a wooden cargo plane that Curtiss-Wright manufactured in Louisville. In 1960, the company was absorbed into the Container Corporation of America, and its Louisville operations were shut down.

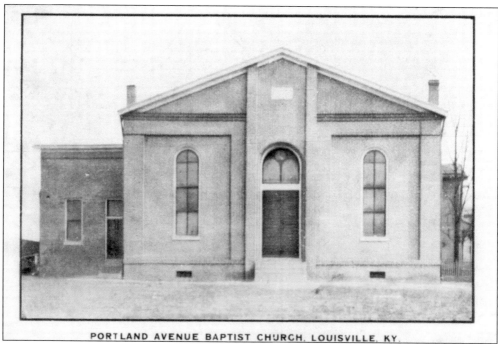

PORTLAND AVENUE BAPTIST CHURCH, LOUISVILLE, KY.

PORTLAND AVENUE BAPTIST CHURCH. A typical neighborhood church in the area west of downtown, this church held services at 3213 Portland Avenue beginning in 1880. The building still stands, but a brick addition has been constructed on the front of the church. In 2008, the church became known as the Guiding Light Baptist Fellowship.

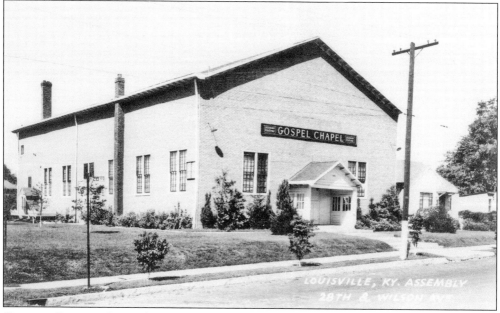

GOSPEL CHAPEL. Located at Twenty-eighth Street and Wilson Avenue, this building was originally the gymnasium for the nearby Anderson Woodworking Company. Later, it became a church called the Gospel Tabernacle before it became the Gospel Chapel. The Gospel Chapel closed about 1982, and the site is now a vacant lot.

Six

SOUTH OF DOWNTOWN

The area thought of as south of downtown is most closely identified with Iroquois Park, one of the three original Olmsted parks, Churchill Downs, the famous racetrack, and Dixie Highway, the road connecting Louisville with Fort Knox, the military base and national gold repository. This area extends from the University of Louisville campus south along Preston Street to the east, Southern Parkway farther west, and to Dixie Highway and the Ohio River, including suburbs such as Shively, Okolona, Pleasure Ridge Park, and Valley Station. A major impetus to residential growth in this area was the World War I training facility known as Camp Zachary Taylor, which covered hundreds of acres in what would be the northeast part of this area between 1917 and 1920. After 1920, the area along Dixie Highway experienced considerable growth as workers from nearby factories moved there to be near their places of employment.

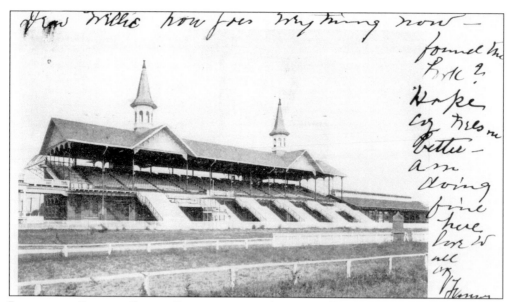

LOUISVILLE JOCKEY CLUB, GRANDSTAND. The Louisville Jockey Club was formed by Meriwether Lewis Clark in 1874, and the first Kentucky Derby was run in 1875. A newspaper report on the Kentucky Derby of 1883 was the first to use the name Churchill Downs, and that name caught on quickly. In 1895, a reorganized Louisville Jockey Club built a new grandstand shown here, featuring the iconic twin spires that have identified the track ever since. Major expansions over the years have greatly altered the appearance of the grandstand, but the twin spires remain.

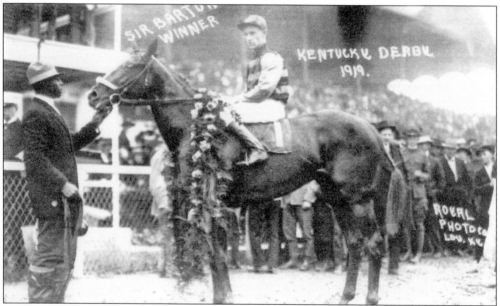

SIR BARTON, 1919 DERBY WINNER. Sir Barton, the 1919 Kentucky Derby winner, was foaled in Kentucky in 1916. He won 8 of 13 races in 1919 and was the first Triple Crown winner. He won the derby by 5 lengths under the steady hand of jockey Johnny Loftus. This real photograph postcard shows Loftus on Sir Barton in the winner's circle after the derby. (Courtesy of Louis Cohen.)

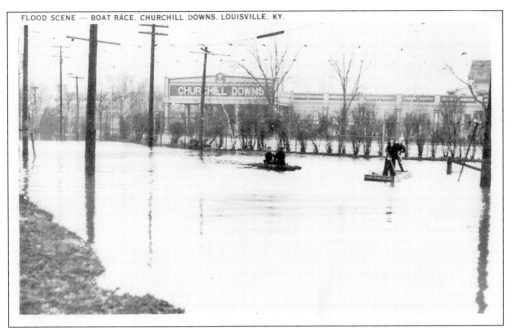

FLOOD SCENE — BOAT RACE. CHURCHILL DOWNS. LOUISVILLE. KY.

CHURCHILL DOWNS, 1937 FLOOD. This common image from the January 1937 Ohio River flood shows boats on Central Avenue in front of Churchill Downs. Despite the destruction of the flood, the Kentucky Derby was on schedule in early May, and visitors saw no trace of the flood's damage at the track.

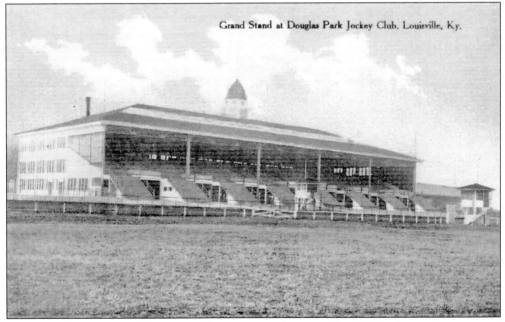

Grand Stand at Douglas Park Jockey Club, Louisville, Ky.

DOUGLAS PARK. Louisville's second horse racetrack opened in 1895 in the south suburbs of the city at the Southside Drive junction with Second Street. Originally built as a racetrack for harness horses, it became a thoroughbred racetrack in 1913. In 1918, the owners sold out to Churchill Downs, and Douglas Park ceased to operate as a racing venue, although it continued to be used for stabling and training horses. (Courtesy of Louis Cohen.)

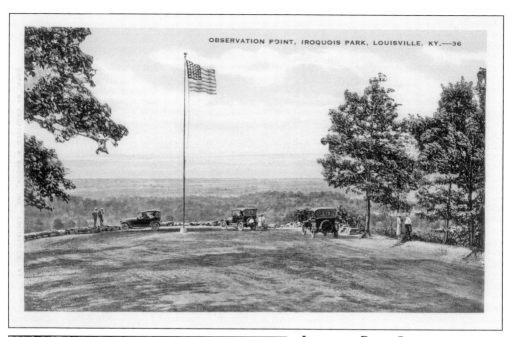

LOUISVILLE, Ky. Autumn in Jacob Park.

IROQUOIS PARK OVERLOOK.
Iroquois Park was one of the three major parks designed by the Olmsted Brothers firm in the early 1890s. It covers 739 acres in the southern part of the city between Taylor Boulevard and Southern Parkway and features rugged, forested knobs. This overlook, presenting a view to the north, was included in the original design and has long been a popular spot.

LADY WALKING IN JACOB PARK.
Jacob Park was named for Mayor Charles Jacob, who in 1889 purchased 313 acres of open land for a park in south Louisville that was incorporated into Iroquois Park in the 1890s. It became officially known as Iroquois Park after 1912, although the original name remained in use for many years.

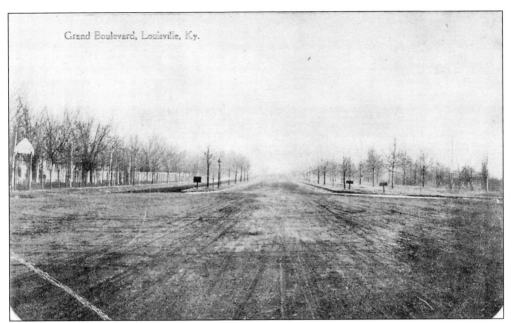

GRAND BOULEVARD WITHOUT AUTOMOBILES. As early as 1910, Grand Boulevard was a continuation of Third Street, which ran to the entrance of Jacob, or Iroquois, Park. By 1920, its name had been officially changed to Southern Parkway.

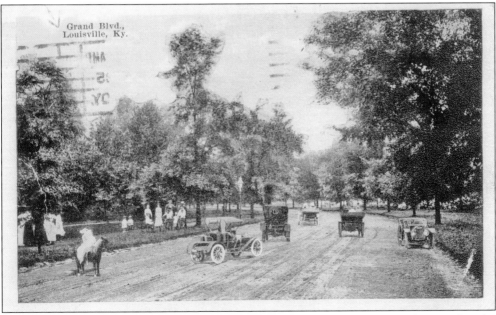

GRAND BOULEVARD WITH AUTOMOBILES. This postcard, published several years after the one above and postmarked in 1929, shows Grand Boulevard (by 1929, Southern Parkway) with a number of automobiles, reflective of the growing popularity and affordability of the family car.

CAMP TAYLOR, LOGO CAMP. Zachary Taylor was one of 16 training centers, or cantonments, that the federal government established after the United States entered World War I in 1917. Camp Taylor was located in a 2,730-acre area bordered by present-day Eastern Parkway, Preston Street, Poplar Level Avenue, and Durrett Lane. Construction of more than 1,400 buildings began on June 26, 1917, and was completed by September 5.

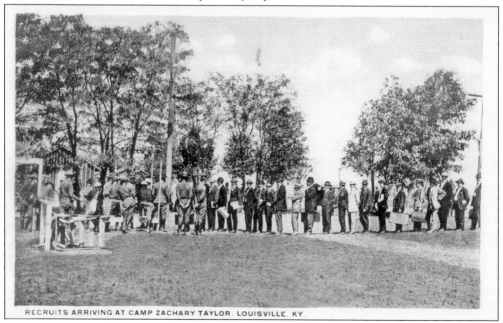

CAMP TAYLOR, RECRUITS ARRIVING. The recruits who trained at Camp Taylor were members of the 84th (or Lincoln) Division, commanded by Maj. Gen. Harry C. Hale, and came from Illinois, Indiana, and Kentucky, all states where Abraham Lincoln had lived. Other units located at Camp Taylor included the 159th Depot Brigade and the Field Artillery Officers Training School.

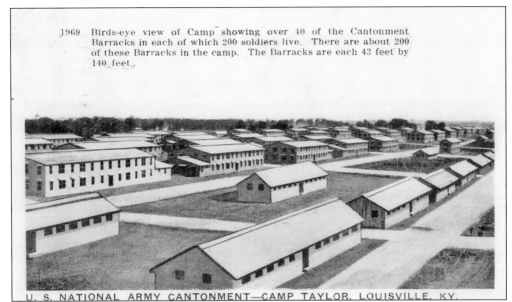

1969 Birds-eye view of Camp showing over 40 of the Cantonment Barracks in each of which 200 soldiers live. There are about 200 of these Barracks in the camp. The Barracks are each 43 feet by 140 feet.

U. S. NATIONAL ARMY CANTONMENT—CAMP TAYLOR, LOUISVILLE, KY.

CAMP TAYLOR, BARRACKS. By the time Camp Taylor opened in September 1917, a total of 365 barracks had been constructed, enough for the 44,000 men who were there at any given time. Eventually, the camp had 399 barracks and 114 officers' quarters. The high water mark of troop strength came in the summer of 1918, when 64,000 men were there. Altogether, more than 150,000 troops received their basic training at Camp Taylor.

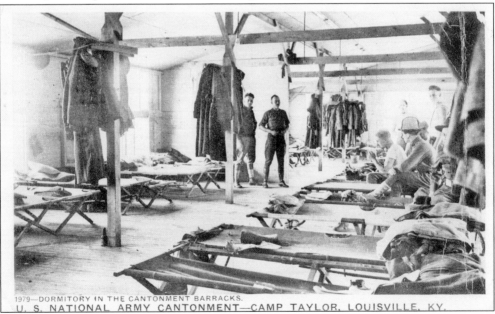

1979—DORMITORY IN THE CANTONMENT BARRACKS.
U. S. NATIONAL ARMY CANTONMENT—CAMP TAYLOR, LOUISVILLE, KY.

CAMP TAYLOR, BARRACKS INTERIOR. The two-story barracks were built to a standard size of 43 feet by 200 to 250 feet in length. Troops slept on the second floor. Iron cots, electric lighting, and large heating stoves were provided, but the living accommodations were simple. Up to 200 men lived in each barrack. After Camp Taylor closed in 1920, some of the buildings were incorporated into the houses that made up the neighborhoods that developed on the former campgrounds.

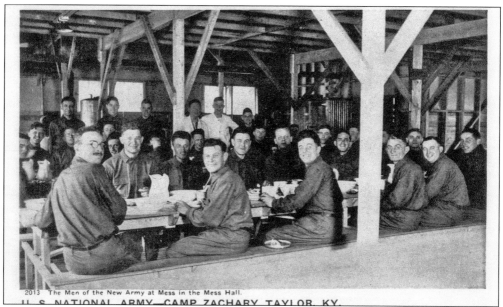

2013 The Men of the New Army at Mess in the Mess Hall.
U. S. NATIONAL ARMY—CAMP ZACHARY TAYLOR, KY.

CAMP TAYLOR, MEN AT MESS. Mess halls, or dining halls, were located on the ground floor of each barrack. They featured bare tables and backless chairs to facilitate simplicity and speed. The floors had half-inch cracks between the boards through which to sweep crumbs and keep flies at a minimum.

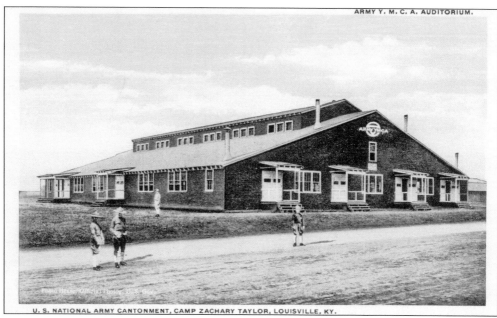

ARMY Y. M. C. A. AUDITORIUM.

U. S. NATIONAL ARMY CANTONMENT, CAMP ZACHARY TAYLOR, LOUISVILLE, KY.

CAMP TAYLOR, YMCA. National social service organizations, such as the YMCA and the Knights of Columbus, had a presence at Camp Taylor and provided support for the trainees through organizing athletic and other activities. These organizations also provided great assistance during the 1918 influenza epidemic, which caused 603 deaths at Camp Taylor out of the 18,000 men who fell ill.

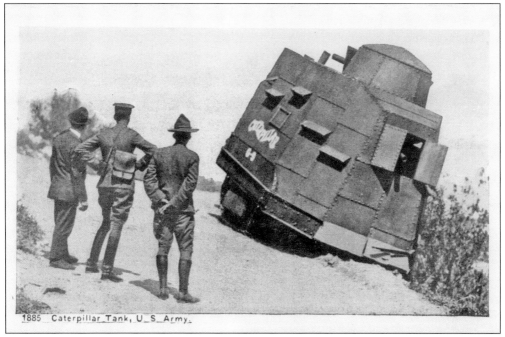

1885 Caterpillar Tank, U_S_Army.

CAMP TAYLOR, TANK TRAINING.
The tank was a new weapon in World War I and an integral part of artillery training. By the summer of 1918, Camp Taylor had become the largest artillery-training center in the United States. An artillery range was established on 18,000 acres of land between West Point and Elizabethtown about 20 miles south of Louisville. After the war, the artillery school was transferred to Camp (now Fort) Knox, southwest of Louisville.

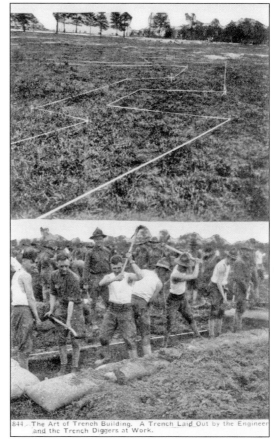

844 The Art of Trench Building. A Trench Laid Out by the Engineer and the Trench Diggers at Work.

CAMP TAYLOR, TRENCH DIGGING.
Virtually every account of the Western Front during World War I contains horrific accounts of life in the trenches. But trenches were a necessary part of the strategy that both sides employed, so trench digging became an important part of the training regimen at Camp Taylor.

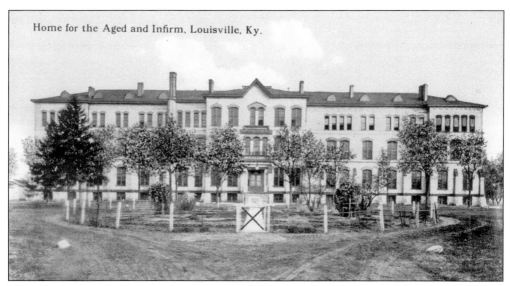

Home for the Aged and Infirm, Louisville, Ky.

HOME FOR THE AGED AND INFIRM. Also known as the almshouse, this was a shelter for poor, elderly, and sick people who had nowhere else to go. The building shown in the postcard opened in 1874 on a site bounded by Seventh Street Road, Manslick Road, Berry Boulevard, and Gagel Avenue. It had 162 rooms and was surrounded by a farm where the able-bodied were expected to work. The home closed in 1953, and the building was torn down to make way for the Southland Shopping Center.

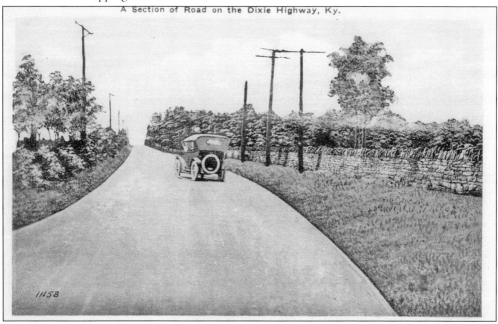

A Section of Road on the Dixie Highway, Ky.

DIXIE HIGHWAY. Part of U.S. 31, Dixie Highway runs southwest out of Louisville to West Point, Kentucky, and then farther south through the state. The Louisville and Jefferson County section was constructed in the early 1920s. Since the 1930s, Dixie Highway has been heavily commercialized and has gained a reputation as one of the state's most dangerous roadways. It was connected with the Watterson Expressway in the mid-1950s and remains a busy thoroughfare and the most direct route to Fort Knox.

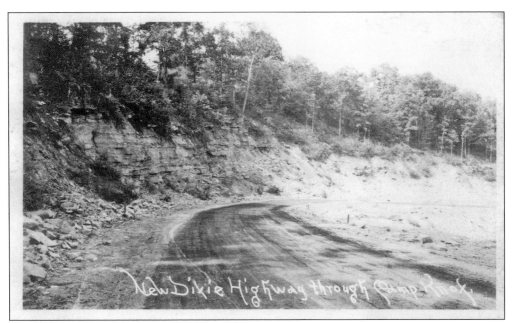

DIXIE HIGHWAY TO CAMP KNOX. This real photograph postcard shows an automobile traveling down a lonely stretch of Dixie Highway toward what was then called Camp Knox. Dixie Highway in Louisville was built along the route of the Louisville and Nashville Turnpike. (Courtesy of Louis Cohen.)

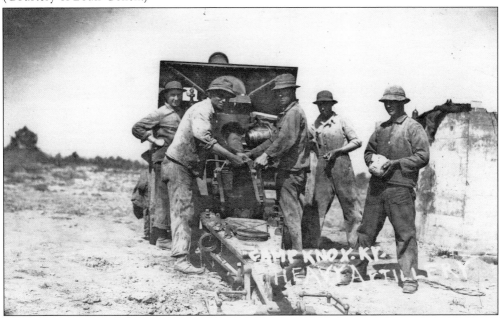

CAMP KNOX: HEAVY ARTILLERY TRAINING. During World War I in June 1918, Congress appropriated $1.6 million to purchase 40,000 acres of land southwest of Louisville. The end of the war halted development of what was called Camp Knox until 1928, when it became a site for summer National Guard training. In 1931, it was designated an artillery-training base. In 1932, the name was changed to Fort Knox, and the federal government made it a gold repository in 1937. (Courtesy of Louis Cohen.)

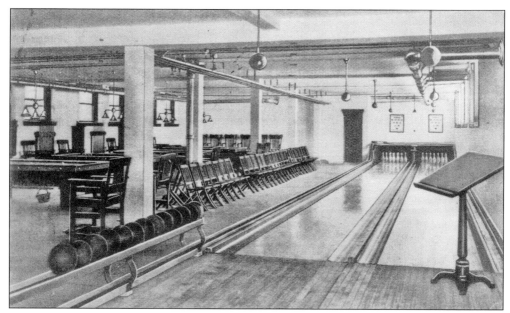

RAILROAD YMCA, INTERIOR. This branch of the YMCA opened in 1912 at Third Street and Central Avenue, near the south Louisville railroad yards and roundhouse. In addition to the recreational facilities shown in the postcard image, it also contained rooms for out-of-town crew members to stay overnight. The Railroad YMCA remained operational until the 1950s, and the building was razed in about 1964. (Courtesy of Louis Cohen.)

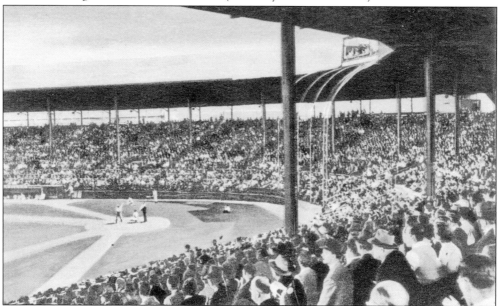

PARKWAY FIELD. Located at Brook Street and Eastern Parkway next to the University of Louisville's Belknap campus, Parkway Field was built for the Louisville Baseball Company in just 63 days at an estimated cost of $250,000. The first game was played on May 1, 1925. The minor-league team moved to a stadium at the new Kentucky state fairgrounds in 1956, and Parkway Field was turned over to the university. It fell into disrepair and was demolished to make way for newer athletic facilities.

Seven

EAST OF DOWNTOWN

A number of different neighborhoods comprise what is thought of as the area east of downtown. Some began as small, independent towns that were annexed by the city, while others were residential neighborhoods whose development was encouraged by the growth of trolley lines in the late 19th century. Cherokee Park, one of the original Olmsted parks, stimulated development east of downtown, and the city's largest (and most prestigious) cemetery, Cave Hill, is also located east of the city center. Broadly speaking, the area east of downtown may be geographically defined by Preston Street on the west, the Ohio River on the north, the farthest outreaches of urbanization on the east, and a line running east on Eastern Parkway from Preston to Newburg Road, and then southeast along Newburg Road on the south.

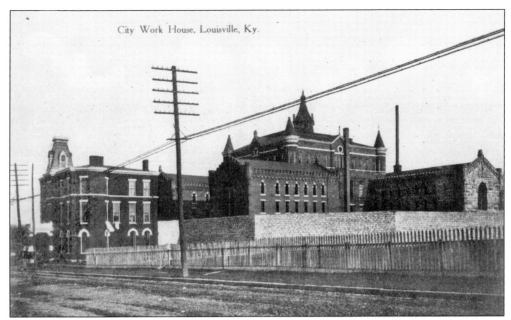

City Work House, Louisville, Ky.

CITY WORK HOUSE. In the 1820s, the city government saw a workhouse as a place to put misdemeanor offenders as well as the poor and sick who had no other place to go. A larger facility, pictured here, was completed in 1878 at 1388 Payne Street. After the workhouse closed in 1954, the building was used as a county driving test center and then as a dog pound. Vacated in 1966, the workhouse burned in 1968.

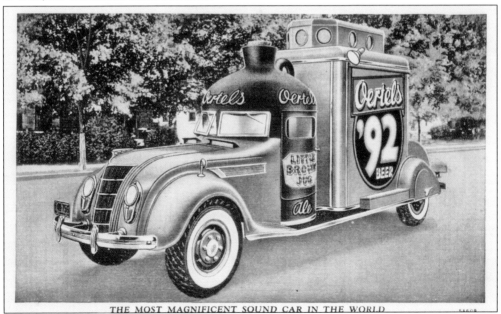

THE MOST MAGNIFICENT SOUND CAR IN THE WORLD

OERTEL'S BEER SOUND CAR. In the late 19th century, many Louisville breweries were located in the Butchertown neighborhood just east of downtown. Oertel's, one of the largest and most successful, operated in the 1300 block of Story Avenue. Once prohibition ended in 1933, Oertel's introduced a new beer, Oertel's 92, with a great deal of fanfare, including this sound car that cost more than $10,000. (Courtesy of Jerry Hornung.)

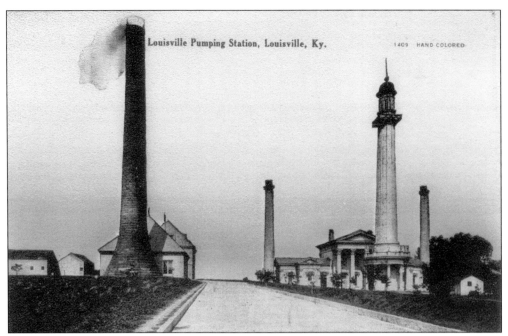

LOUISVILLE PUMPING STATION. The Louisville Pumping Station, featuring the landmark Water Tower, is located at the foot of Zorn Avenue. The complex was built between 1857 and 1860. The water tower is 169 feet high, and the adjacent Greek Revival building held the pumping equipment. The pumping station was replaced by a newer one in 1909, leaving the buildings vacant for many years. The Louisville Visual Art Association has leased the equipment building from the water company since 1980.

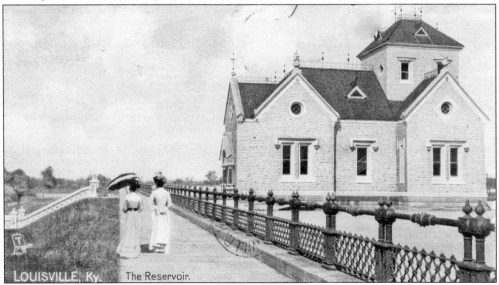

RESERVOIR PARK WALKWAY. The reservoir shown on this postcard was created in 1879 when the Louisville Water Company began to pump river water up what was then Pipe Line Avenue (now Zorn Avenue) and across Brownsboro Road. The reservoir boasted a modern filtration system. An elaborate building, adorned with water-related architectural details, was erected, and a walkway was constructed around the reservoir that is still used today.

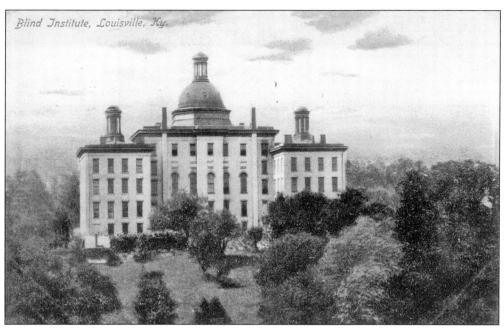

Blind Institute, Louisville, Ky.

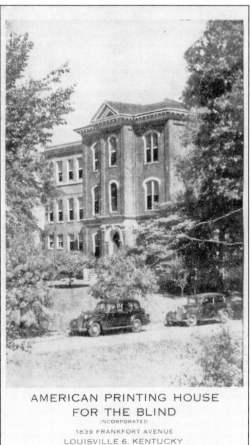

AMERICAN PRINTING HOUSE
FOR THE BLIND
INCORPORATED
1839 FRANKFORT AVENUE
LOUISVILLE 6. KENTUCKY

BLIND INSTITUTE. This institute, more formally known as the Kentucky Institute for the Education of the Blind and now the Kentucky School for the Blind, was chartered in 1842. When the first blind institute burned in 1851, this Greek Revival building was constructed in the 1800 block of Frankfort Avenue and opened in 1855. Its three domes were visible from any part of the city. The building was razed in 1967 and replaced by a more modern facility.

AMERICAN PRINTING HOUSE FOR THE BLIND. The American Printing House for the Blind is a private corporation located at 1839 Frankfort Avenue, on the site of (but not part of) the Kentucky School for the Blind. Dempsey Sherrod, who was blind himself, founded the school in 1858 to meet the need for tactile books for blind students. In 1883, the printing house built the structure shown on this publicity brochure for its operations. (Courtesy of Louis Cohen.)

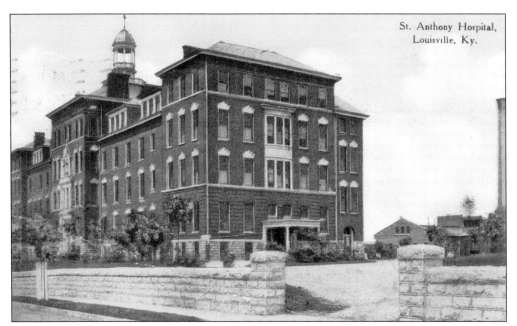

ST ANTHONY'S HOSPITAL. Founded in 1900 by Franciscan Sisters at 1513 St. Anthony Place, this hospital was an important general hospital for many years in the area east of downtown. In 1995, it was taken over by Vencor, a for-profit health care business, and after the demise of that company a few years later, it became Kindred Hospital, specializing in long-term patient care.

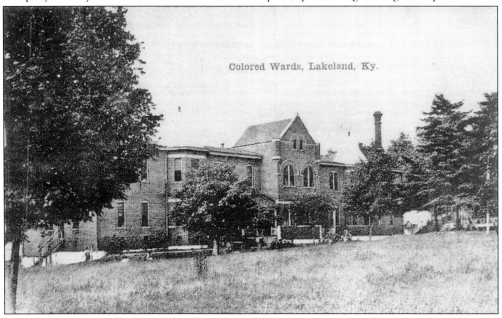

LAKELAND, COLORED WARDS. Popularly called Lakeland Hospital, but more formally known as Central State Hospital, this mental institution was established in 1869 in rural eastern Jefferson County. Originally a home for juvenile delinquents, it became a mental hospital in 1873. In an age of racial segregation, separate wards for African Americans were needed, and these were constructed in the late 1800s. The buildings shown were razed in 1986. (Courtesy of Louis Cohen.)

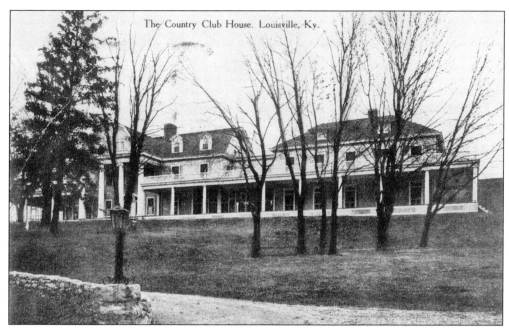

LOUISVILLE COUNTRY CLUB, CLUBHOUSE. An outgrowth of the merger of the Louisville Golf Club and the Country Club of Louisville, the Louisville Country Club relocated from land along River Road owned by the water company to higher ground between Mockingbird Valley Road and Indian Hills Trail.

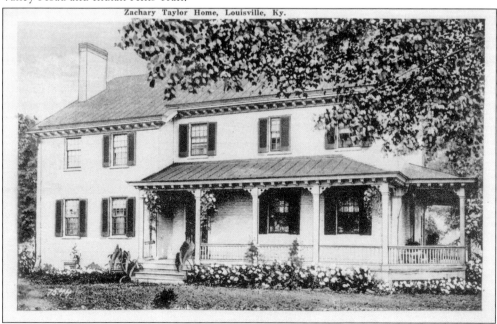

ZACHARY TAYLOR HOUSE. Called Springfield, this was the boyhood home of the 12th president. The house was constructed in the Georgian style, with two large rooms on each floor and an attic loft. The house passed out of the Taylor family in 1868, but it has remained in private hands ever since. Damage from a 1974 tornado spurred an extensive renovation project, and the house now looks much as it did when Zachary Taylor lived there.

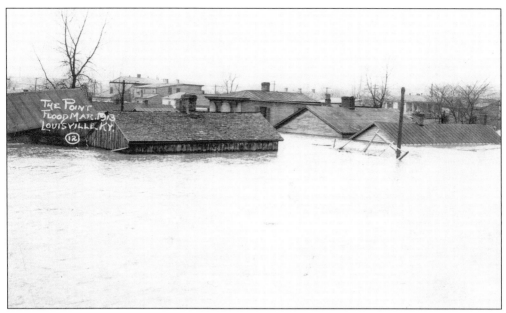

THE POINT, 1913 FLOOD. The Point was a name given to an area that existed east of downtown along the Ohio River. Settlement in this low-lying area began in the early 19th century, and by 1900, the lower part was a crowded area of modest homes, taverns, and stores while the upper part had large mansions and other fine homes. Frequent floods, however, particularly that of 1913, destroyed most of the structures on the Point. (Courtesy of Louis Cohen.)

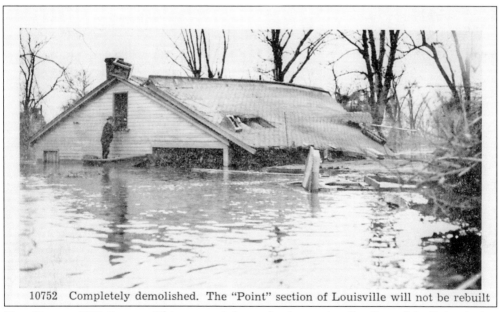

10752 Completely demolished. The "Point" section of Louisville will not be rebuilt

THE POINT, 1937 FLOOD. This postcard shows the devastating flooding of the Point during the January 1937 flood. Although the postcard notes that the area "will not be rebuilt," it took one more flood in 1945 for the Point to be declared uninhabitable.

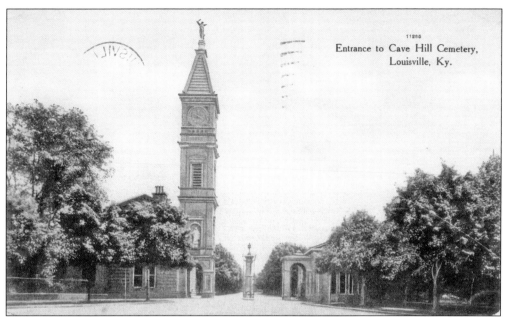

Entrance to Cave Hill Cemetery,
Louisville, Ky.

CAVE HILL CEMETERY, ENTRANCE.
Cave Hill, the largest cemetery
in Louisville, was dedicated in
1848. William H. Redin designed
this entrance at the intersection
of Broadway, Baxter Avenue, and
Cherokee Road in 1880. A clock
tower and bell were added in 1882.
The cemetery now spans 296 acres and
boasts carefully planned landscaping
and plantings. Cave Hill has become
the cemetery of choice for many of
Louisville's most prominent families.

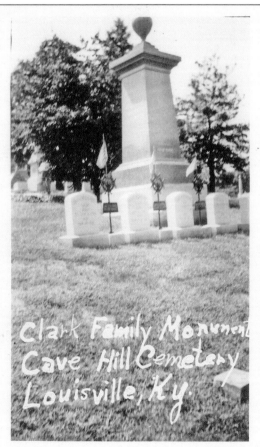

**CAVE HILL CEMETERY, THE
CLARK FAMILY MONUMENT.** This
real photograph postcard shows the
family plot of George Rogers Clark,
the Revolutionary War hero who
lived in the Louisville area after the
war. His grave is on the far left in the
photograph. The other graves, from left
to right, are those of Capt. Edmund
Clark (1762–1815), Gen. Jonathan
Clark (1750–1811), Sarah Hite, wife of
Jonathan (1758–1819), and John Hite
Clark (1785–1820).

94

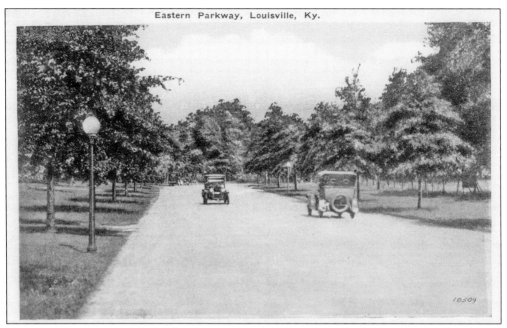

EASTERN PARKWAY. This major east-west thoroughfare was built in stages between 1910, when it reached only from Barrett Street to Baxter Avenue, to 1926, when it had been extended to its present length from Third Street east to the entrance to Cherokee Park. This postcard, postally unused, appears to date from the mid-1920s, but it is uncertain which part of Eastern Parkway is shown in the image.

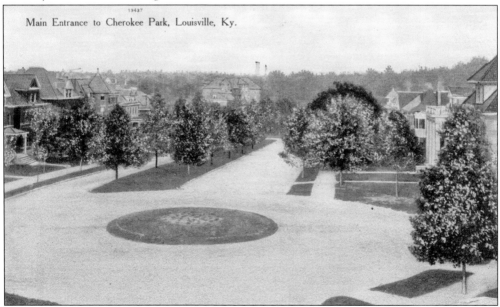

Main Entrance to Cherokee Park, Louisville, Ky.

CHEROKEE PARK, MAIN ENTRANCE. In the early 1890s, Louisville's board of park commissioners hired the Olmsted Brothers firm of New York to design the first parks—Cherokee, Shawnee, and Iroquois—in different parts of the city. The 409-acre Cherokee Park is located in the eastern part of the city. It is notable for its winding roadways, its decorative bridges over Beargrass Creek, and its statue of Daniel Boone.

CRESCENT COURT, ENTRANCE GATE. Crescent Court is a short residential street in Crescent Hill, an older neighborhood between Brownsboro Road on the north and Lexington Road on the south. Crescent Court runs between Frankfort Avenue and Grinstead Street just east of Kennedy Street; the arch over the street entrance on Frankfort Avenue has been removed.

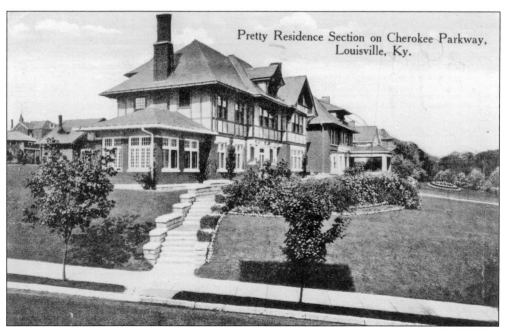

RESIDENCE NEAR CHEROKEE ROAD. The development of Cherokee Park was an impetus to the development of large and elegant homes on Cherokee Road and other streets near the park. This home, at the corner of Cherokee Parkway (near Cherokee Road) and Willow Street, was designed by John Bacon Hutchings and built in 1910 for George W. Kremer Sr. Kremer married Elizabeth Fehr and was secretary-treasurer of the Fehr Brewing Company for 30 years.

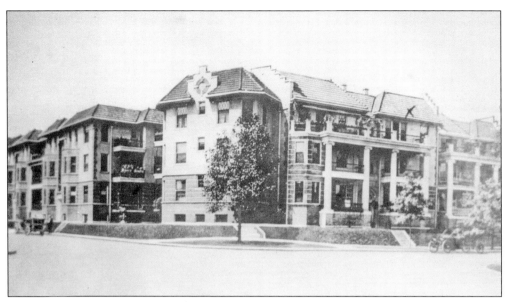

PARKVIEW APARTMENTS. In addition to the elegant homes that filled the streets around Cherokee Park, apartment houses offering the same kind of comfortable living were being constructed. One of these, shown in this real photograph postcard from the 1920s, was Parkview Apartments, built in 1907 (and spelled Park-View at that time) and located at the traffic circle where Cherokee Road and Cherokee Parkway intersect. The Parkview is still functioning as an apartment house.

COMMUTER RAIL STATION. Between 1903 and the mid-1930s, the Louisville and Interurban Railroad Company operated lines from downtown Louisville to a number of outlying towns in Kentucky and southern Indiana. This real photograph postcard shows the Baxter Avenue station east of downtown, probably a stop on the line that went to Anchorage. The station remains on the Baxter Avenue overpass, although it has deteriorated over the years.

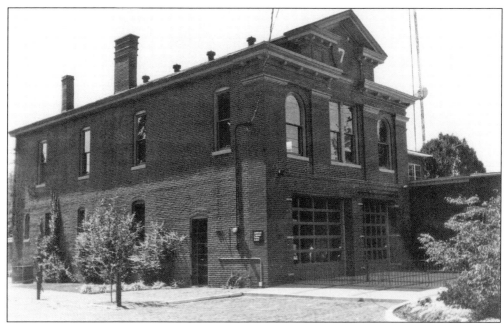

FIRE STATION, 1330 BARDSTOWN ROAD. As Louisville spread to the south and east after the 1890s, the need for fire protection had to be met with the construction of new fire stations. This real photograph postcard, dated 1924, shows the station at 1330 Bardstown Road that was built in 1900 for Chemical Company No. 4. The fire station is still an integral part of the Louisville Fire Department.

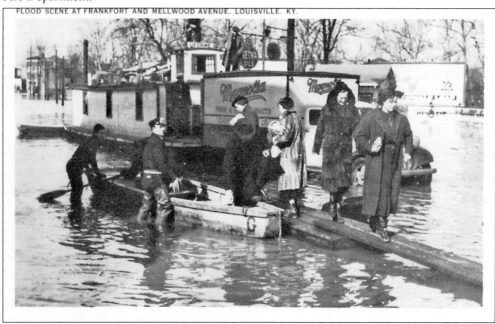

1937 FLOOD, MELLWOOD STREET AND FRANKFORT AVENUE. Much of the east part of Louisville past this point was spared by the January 1937 flood. This postcard view shows a boat delivering a woman safely to dry land near the intersection of Frankfort and Mellwood Avenues.

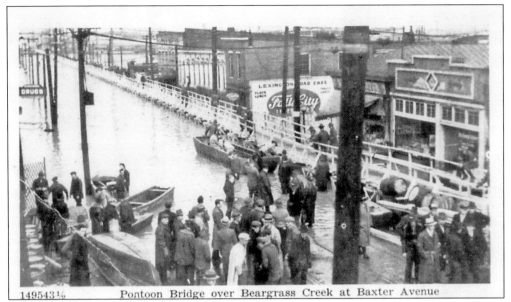

14954 3 1/2 Pontoon Bridge over Beargrass Creek at Baxter Avenue

1937 FLOOD, PONTOON BRIDGE. One of the heroic measures of flood relief was the construction of a pontoon bridge from the 900 block of East Jefferson Street to the intersection of Baxter and Barrett Avenues. The bridge utilized some 1,400 whiskey barrels and was built by 300 workers in a single day. It allowed many Louisvillians to leave their flooded homes and get to the dry land of the Highlands.

KENTUCKY
MILITARY
INSTITUTE, NEAR
LOUISVILLE. KY.

KENTUCKY MILITARY INSTITUTE. Opened in 1845, the Kentucky Military Institute (KMI) offered high school and college classes from 1893 to 1971 on a campus on the site of the plantation formerly owned by Stephen Ormsby located on LaGrange Road. This 1909 postcard shows one of the school's buildings there. Under the leadership of Charles Wesley Fowler, KMI made extensive improvements as the school thrived in the early 20th century. The school closed in 1971, partly due to anti-Vietnam War sentiments.

COX'S AERATED LAKE

COX'S AERATED LAKE. This popular summer recreation spot of the 1930s and 1940s was located on English Station Road near Anchorage, a suburb east of Louisville. It featured picnic areas, a dance pavilion, and of course the swimming lake, in which there was an underwater system for pumping air into the water, supposedly keeping it continually fresh. Cox's Aerated Lake closed in the 1950s, and the lake was drained.

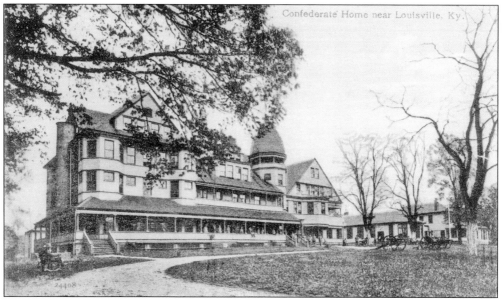

CONFEDERATE HOME, PEWEE VALLEY. Authorized by the state legislature in 1902, the Confederate Home for aged and infirm veterans from the Civil War was built in Pewee Valley east of Louisville. An existing home on the site, Villa Ridge, was purchased, renovated, and opened in October 1902. By 1904, the home housed some 300 veterans. The Confederate Home closed in 1934 when the five surviving veterans were transferred to the Pewee Valley Sanitarium. The building has since been razed.

Eight

THE RIVER

No book on the history of Louisville would be complete without mention of the Ohio River, which, of course, is the reason that Louisville is where it is. The city was initially founded as a portage spot around the Falls of the Ohio and developed as a center of river commerce. Eventually dams and the Louisville and Portland Canal were built to circumvent the falls, and bridges were constructed to cross the river to Indiana. The city also suffered from periodic floods when the river overflowed its banks, sometimes by a very large amount. For many Louisvillians, however, the river was also a prime recreational area for swimming, boating, and excursions up or down the river in paddle wheel steamboats.

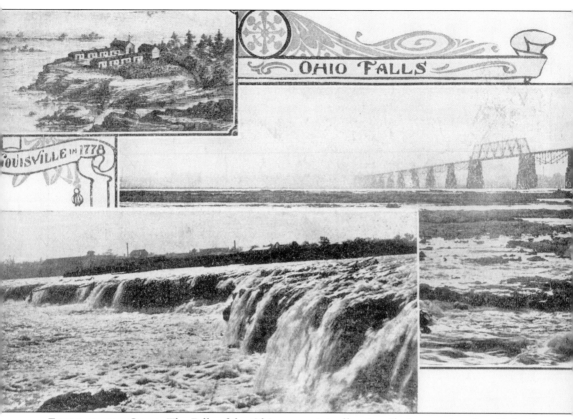

FALLS OF THE OHIO. The Falls of the Ohio was originally a 2-mile-long series of rapids in the Ohio River that formed in the Devonian Period and provided the impetus for the founding of Louisville in Kentucky, and New Albany, Clarksville, and Jeffersonville in Indiana. In 1830, the Louisville and Portland Canal was the first water route around the falls, and the first bridge over the river opened in 1870.

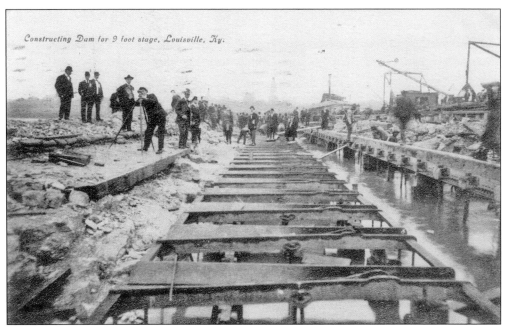

CONSTRUCTING DAM FOR 9-FOOT STAGE (ABOVE) AND GOVERNMENT DAM (BELOW).
In 1899, the local corps of engineers staff decided that a dam was needed from the entrance of the Louisville and Portland Canal to the Indiana shore in order to deepen the canal from 6 to 9 feet. In 1899, work began on the dam, which consisted of 11 sections, and it was completed in 1910. This was one of the first major civil engineering projects using the newly developed Portland cement. When completed, the dam was 5,247 feet long, and the Louisville District Engineer said, "No other moveable dam of as great width [*sic*] or contending against such adverse conditions is known to exist anywhere. The work was therefore more or less experimental and in view of the knowledge available at the time is very successful." (Courtesy of Louis Cohen.)

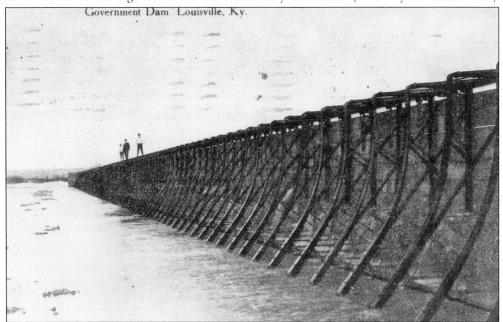

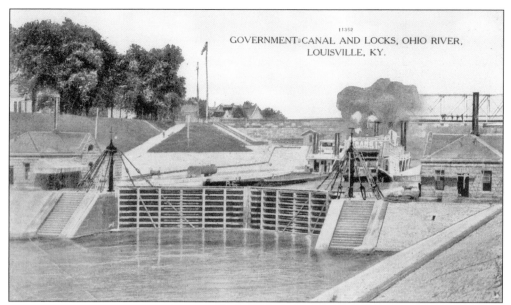

GOVERNMENT LOCKS. The first locks, part of the Louisville and Portland Canal, opened in 1830. As riverboats became larger, the locks were rebuilt (or new locks were constructed) to accommodate them, which happened in 1872, 1921, and 1961. A further expansion was undertaken in about 2005. The locks shown in this postcard are the old 50-foot-wide 1830 version.

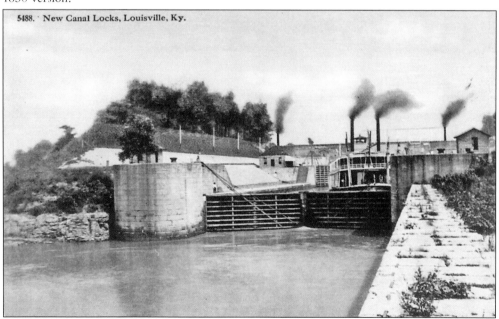

CANAL LOCKS. The first enlargement of the locks at Louisville, shown here, came in 1872. They were replaced by the first set of modern locks that opened in 1921 and were part of the Ohio River canalization scheme that included 53 new locks along the entire length of the river. In 1961, a new set of locks opened that measured 110 feet wide by 1,200 feet long. They were named the McAlpine Locks and Dam in honor of William McAlpine, a longtime district engineer.

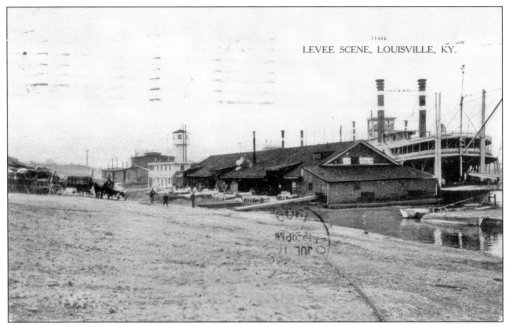

LEVEE SCENE. For many years, until railroads displaced steamboats as the major commercial transportation means, the levee area along Louisville's riverfront between Third and Sixth Streets was a busy place. The crowds of workers are not there in this 1909 postcard, but the image gives an idea of what the area looked like.

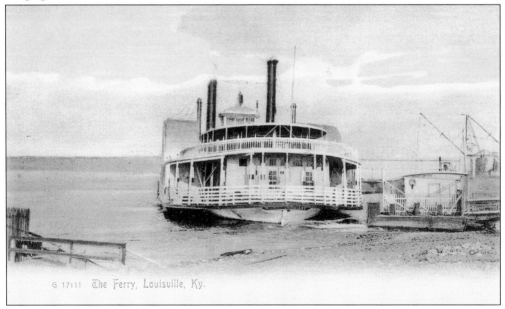

OHIO RIVER FERRY. Ferry service on the Ohio River between Louisville and southern Indiana started as early as 1794, and steam-powered ferries began operating in the 1830s. Ferry service between Louisville and New Albany ended in 1896, but ferries between Louisville and Jeffersonville continued to operate until 1929 when the George Rogers Clark (or Municipal) Bridge was completed. This postcard shows the ferry, *City of Jeffersonville,* built in 1891 by the Howard Boat Works in Jeffersonville and used as a ferry until 1914.

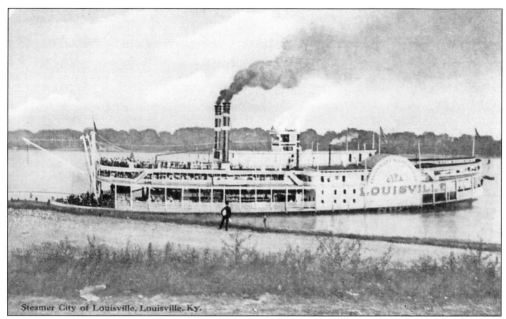

Steamer City of Louisville, Louisville, Ky.

STEAMER *LOUISVILLE*. Built in Jeffersonville by the Howard Boat Works in 1894, this steamboat made a record run from Louisville to Cincinnati in 9 hours and 42 minutes, also in 1894. This record still stands. The *Louisville* sank in Cincinnati in 1918 after it had gone there to be considered as a World War I troop carrier.

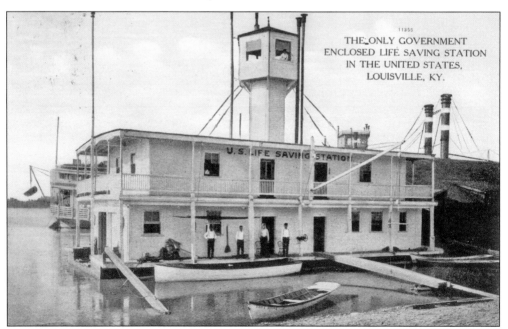

THE ONLY GOVERNMENT
ENCLOSED LIFE SAVING STATION
IN THE UNITED STATES.
LOUISVILLE, KY.

U.S. LIFE SAVING STATION

LIFE SAVING STATION. In 1881, Will Hays, a local journalist and noted songwriter, convinced U.S. representative Albert Willis of the need for a permanent lifesaving station in Louisville. Congress authorized its construction and a floating station with a lookout tower, shown here, was completed in 1881. The service merged with the U.S. Coast Guard in 1915 and continued to operate until 1972, when it was turned over to the city.

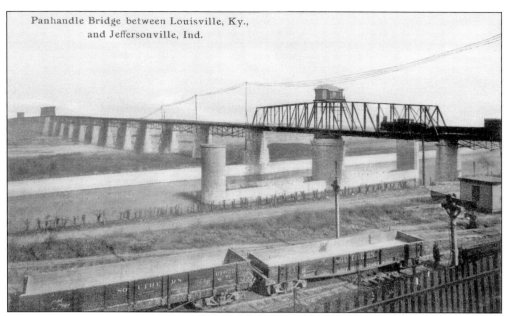

Panhandle Bridge between Louisville, Ky., and Jeffersonville, Ind.

PANHANDLE BRIDGE. Also known as the Fourteenth Street Bridge, this railroad bridge was the first built across the Ohio River. The bridge was completed in 1870. A few years later, the bridge came under the control of the Pennsylvania Railroad, and the name Panhandle Bridge became popular because of the way the route looked on a map. Heavy traffic led to the building of a new, double track bridge on the old piers in 1919, and the bridge remains in use today.

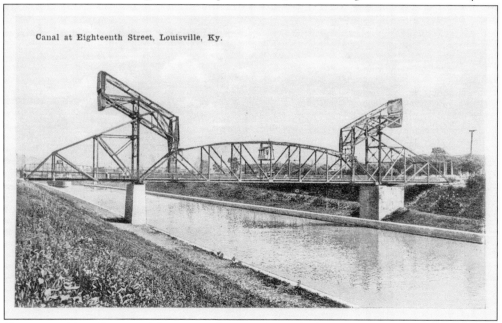

Canal at Eighteenth Street, Louisville, Ky.

CANAL AT 18TH STREET. This postcard image shows the bridge that connected the island of Shippingport to the mainland on the south side of the river. The building of the Louisville and Portland Canal had cut Shippingport off from the mainland, and this bridge was constructed so that residents of Shippingport could have access to Louisville. In the 1950s, the government bought out all the remaining inhabitants of Shippingport and now owns the entire island.

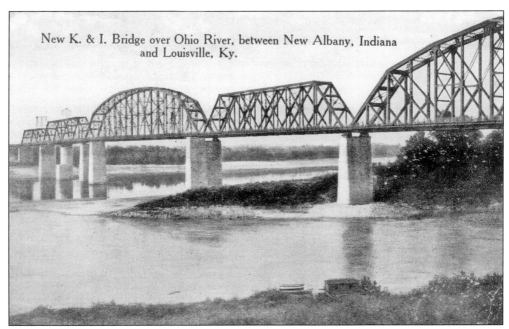

New K. & I. Bridge over Ohio River, between New Albany, Indiana and Louisville, Ky.

K&I BRIDGE. The Kentucky and Indiana Bridge (also known as the Thirty-second Street Bridge) was promoted by the Monon Railroad, which wanted independent access to Louisville. The bridge opened in 1886 and was rebuilt in 1913 to allow for automobiles and increased rail traffic. It was closed to auto traffic in 1979 because of its deteriorating condition and the availability of other bridges, but it is still used for rail traffic.

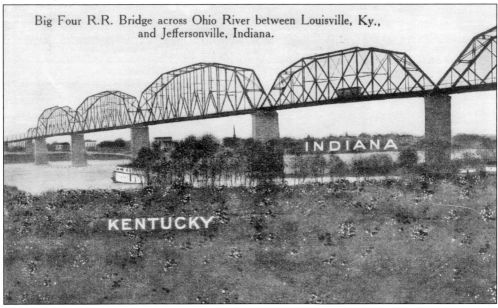

Big Four R.R. Bridge across Ohio River between Louisville, Ky., and Jeffersonville, Indiana.

BIG FOUR BRIDGE. The Big Four stands for the Chicago, Cincinnati, Cleveland, and St. Louis Railroad, and the bridge of that name was built between 1888 and 1895 over the protests of riverboat businessmen. The construction of this bridge cost 37 lives. Railroad use of the bridge ended in 1968, and the approaches were removed. As of 2009, plans were afoot to build new approaches and turn the bridge into a trans-river walkway.

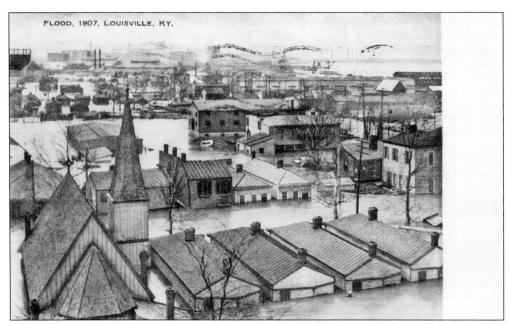

FLOOD, 1907, LOUISVILLE, KY.

1907 FLOOD SCENE. Not as large as the 1884, 1913, or 1937 floods, the January 1907 flood nevertheless caused considerable damage both in Louisville and across the river in Indiana. The *Courier-Journal* reported that the Point was "inundated" but that there was no loss of life. This postcard image does not specify what part of Louisville is depicted, but given the high water level, it may well be the Point.

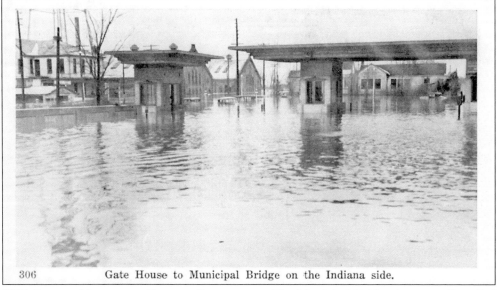

306 Gate House to Municipal Bridge on the Indiana side.

1937 FLOOD, MUNICIPAL BRIDGE GATEHOUSE. The Municipal Bridge (now usually called the Second Street Bridge) connects downtown Louisville and Clarksville, Indiana, and opened in 1929 as a toll bridge. This 1937 flood postcard shows the tollgates on the Indiana side of the bridge.

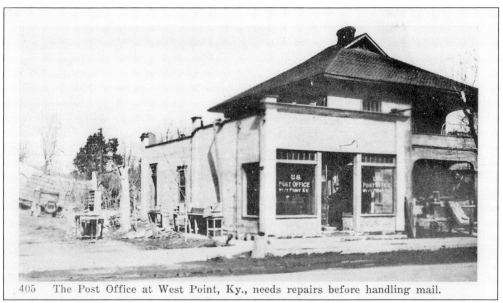

405 The Post Office at West Point, Ky., needs repairs before handling mail.

1937 FLOOD, POST OFFICE AT WEST POINT. West Point, a small suburb southwest of Louisville, suffered in the 1937 flood as did so many other small towns along the Ohio River. This postcard image shows the West Point post office after floodwaters had receded, leaving debris to be cleaned up virtually everywhere.

QSL CARD. QSL cards are exchanged between amateur, or "ham," radio operators to acknowledge receipt of transmissions. Often, ham radio operators are an important link to the outside world during natural disasters such as the 1937 flood. This 1927 QSL card from Carl Newman of Louisville dates back to a relatively early point in the history of ham radio. Interestingly, Newman might well have used his radio in public service during the flood, especially since his residence in the Camp Taylor neighborhood probably escaped flooding.

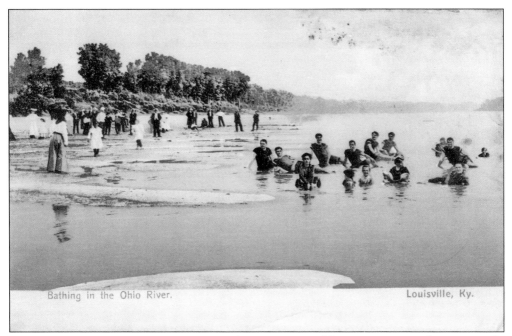

Bathing in the Ohio River. Louisville, Ky.

SWIMMING IN THE OHIO RIVER. Since there were no public swimming pools in Louisville until 1915, the Ohio River was the only place where people could swim. Swimming in the river was common by the 1890s, and the beach at Western (Shawnee) Park was popular as were those at Fontaine Ferry Park and White City. By the 1960s, increasing pollution and canal activity had made the river less suitable for swimming.

ROCK ISLAND, OHIO RIVER. Rock Island was one of several destinations on or along the Ohio River that one could reach by steamboat in the early 20th century. By 1940, along with Corn Island, Goose Island, and much of Sand Island, it was gone, buried under a hydroelectric plant built in conjunction with dams and canalization projects on the river.

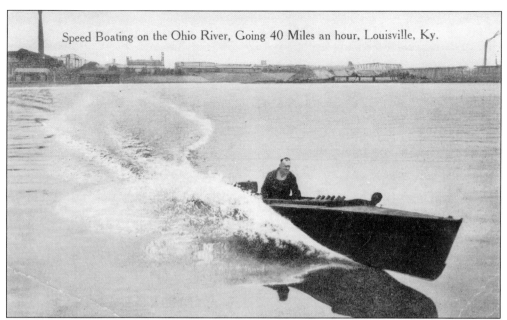

Speed Boating on the Ohio River, Going 40 Miles an hour, Louisville, Ky.

SPEED BOATING ON THE OHIO RIVER. While the date of this postcard is not known, speedboat (or powerboat) racing was occurring on the Ohio River at Louisville by the 1920s and in all likelihood, earlier. The postcard notes that the boat is going 40 miles an hour, which was possible for well-equipped speedboats by about 1910.

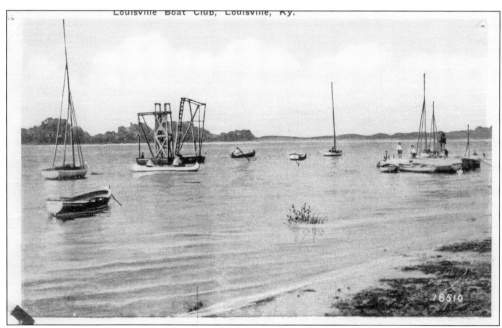

Louisville Boat Club, Louisville, Ky.

LOUISVILLE BOAT CLUB. Founded in 1879, the Louisville Boat Club was originally situated on a wharf boat near the levee area at the foot of Sixth Street. Members were mostly wealthy Louisville businessmen who enjoyed sailboat races and large parties during the summer. By the 1920s, the club had moved to new quarters on Upper River Road, as seen in this postcard image.

Nine

ACROSS THE RIVER

The three southern Indiana towns of New Albany, Clarksville, and Jeffersonville lie across the Ohio River from Louisville. While these towns are much smaller than Louisville, they each have their own river heritage, and their histories are inextricably bound up with that of their larger neighbor on the south side of the river. New Albany became well known in the mid–19th century for its glass industry and steamboat building, and later, in the 20th century, developed an excellent reputation in the wood veneer trade. Clarksville was the place where George Rogers Clark lived for many years after the Revolutionary War, and it later became the home of the Indiana State Reformatory. Jeffersonville was renowned for the Howard Boat Works, which turned out some of the finest steamboats to ply the Ohio and Mississippi Rivers. All three towns were linked with Louisville, first by ferry and then by bridge, and all three suffered with Louisville in the 1937 Ohio River flood. It is therefore fitting that these three towns should be included in this postcard history of Louisville.

GREETINGS FROM NEW ALBANY. Examples of this postcard style may be found for many U.S. towns and cities. For New Albany, the images shown, clockwise from the top left, are the Floyd County Courthouse, the Carnegie Library, Spring Street looking east from State Street, the U.S. Courthouse and Post Office, and the Falls of the Ohio. The postcard bears a 1907 postmark.

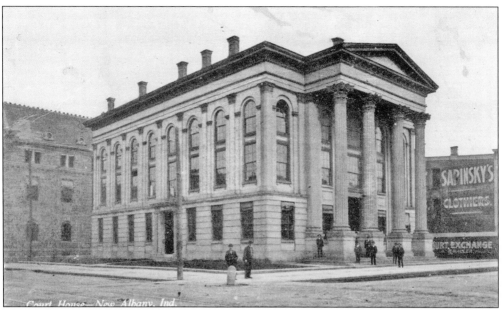

COURTHOUSE, NEW ALBANY. The old Floyd County Courthouse, shown here on this 1908 postcard, was located at the southeast corner of Spring and State Streets in downtown New Albany. The Greek Revival building was constructed in 1866 at a cost of $127,700 and was razed in 1963, when a new structure was built two blocks to the west. The columns from the old courthouse were saved and stand in front of the new building.

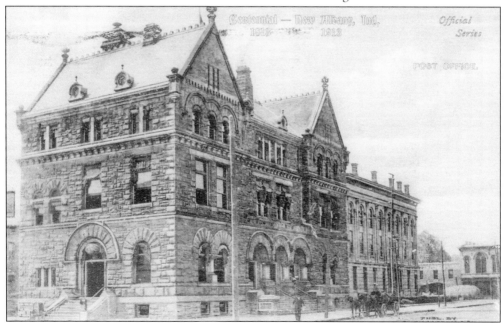

POST OFFICE, NEW ALBANY. This Romanesque Revival building was located on the southwest corner of Spring and Pearl Streets. Built in 1889 at a cost of $100,000, it contained not only a post office but also other government offices. It served the city until the mid-1960s, when a new post office (1962) and a new federal building (1966) had been built in separate locations. The old post office was demolished in 1970.

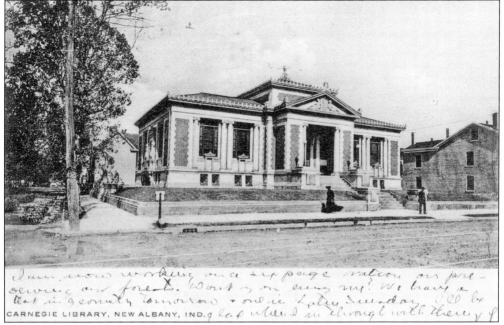

CARNEGIE LIBRARY, NEW ALBANY. Considered one of the finest Carnegie libraries in Indiana, this building opened in 1904 at 201 East Spring Street. The city council donated the land on which it was built. It remained the county library until 1969, when a new structure was opened a few blocks to the west. Now it is the Carnegie Center for Art and History, featuring exhibits of local history and regional and national art.

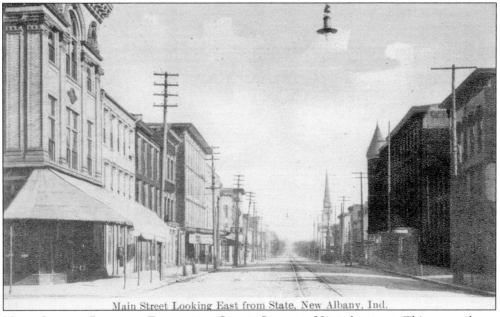

Main Street Looking East from State, New Albany, Ind.

MAIN STREET LOOKING EAST FROM STATE STREET, NEW ALBANY. This scene shows one of New Albany's principal streets as it looked in about 1910. On the left is the Sapinsky Building and on the right the Clapp Block and the Second Baptist Church, which lost its steeple to lightning in 1914.

VINCENNES AND SHELBY STREET SCHOOL, NEW ALBANY. Awkwardly named the Vincennes and Shelby Street School because of its location at that street corner, this elementary school opened in 1893. In 1923, the school became known as the Cora Martin School to honor a legendary teacher. After 1943, it served as an annex to New Albany High School until its demolition in 1979 to clear space for a new high school swimming pool.

Vincennes and Shelby Street School, New Albany, Ind.

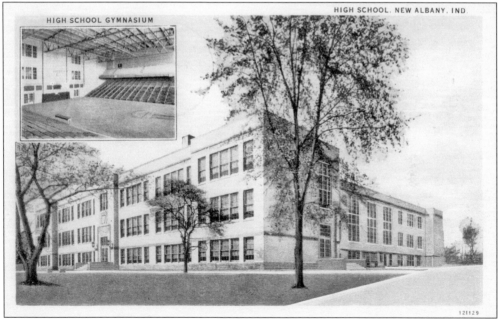

NEW ALBANY HIGH SCHOOL. A new high school for New Albany opened on Vincennes Street in 1928. The site had been occupied by a building known as the Old Woolen Mills, which in 1917 was owned by the Hercules Motor Works, automakers. The cyclone of 1917 destroyed the building, and several years later, the site was acquired for the new high school. The school was financed by a $300,000 bond issue, with local boosters raising another $75,000 for the gymnasium. Although it has undergone several expansions, the school is still at this location.

COLORED SCHOOL, NEW ALBANY. Also known as Scribner High School, this school was founded in 1880 when a state law mandated free public education for African American children. This structure was built in 1906 and located on West Spring Street. Its last class graduated in 1951, after which students were integrated into New Albany High School. The old school was torn down in 1959 to clear space for the new City-County Building.

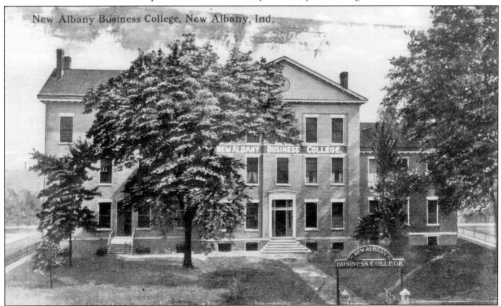

NEW ALBANY BUSINESS COLLEGE. The New Albany Business College was established in 1865 and held classes in this building on the southwest corner of East Ninth and Main Streets from 1908 to 1917. This building was erected in 1852 for Indiana Asbury Female College, which used it until 1887, after which it was occupied by others until 1909, when the business college moved in. The federal government used it during World War I, and it was razed in 1919. The DePauw Apartments were built on the site in 1925.

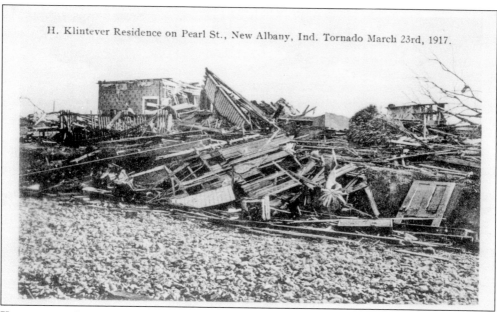

H. Klintever Residence on Pearl St., New Albany, Ind. Tornado March 23rd, 1917.

KLINTEVER RESIDENCE, 1917 CYCLONE, NEW ALBANY. A devastating tornado swept through much of New Albany on March 23, 1917, leaving more than 50 people dead and destroying property over 90 city blocks. This house, at 1132 Olden Street, belonged to Herbert M. Klinstiver (not Klintever), who was a printer for the *Public Press*, a Democratic newspaper in New Albany. A friend in the house, Mrs. Charles Schray, was seriously injured in the tornado, and Klinstiver moved to 115 Union Street.

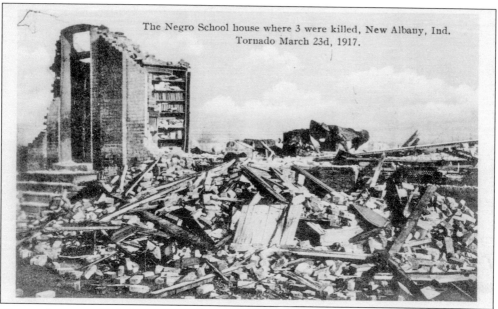

The Negro School house where 3 were killed, New Albany, Ind. Tornado March 23d, 1917.

NEGRO SCHOOL, 1917 CYCLONE, NEW ALBANY. Destroyed in the tornado, this school was the Olden Street School, located at the northwest corner of Union and Olden Streets. Two students, both six years old, and the school janitor were killed when the building collapsed. The school was not rebuilt. By 1925, a new State Street School opened, and the African American students were placed in the old Jackson Street School at 230 Jackson Street not far away.

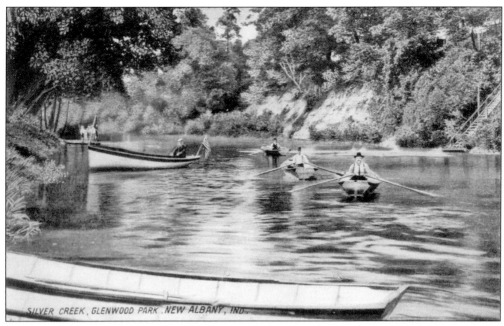

SILVER CREEK, GLENWOOD PARK, NEW ALBANY, IND.

SILVER CREEK. Silver Creek constitutes the boundary between Floyd and Clark Counties. Over the years it has been dammed in several places, creating recreational areas for boating such as the one shown in this postcard view that dates to about 1909.

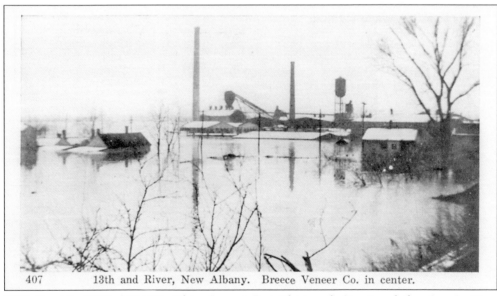

407 13th and River, New Albany. Breece Veneer Co. in center.

1937 FLOOD, NEW ALBANY. This view, at East Thirteenth Street and the river in New Albany, shows flood damage at its worst. The nearly submerged buildings are those of the New Albany Veneer Company factory. After the flood, John T. Breece leased the property and restored the plant. As Breece Veneer and Panel Company, it manufactured plywood for furniture until 1969.

Peak of one of the Big Hills in Green Valley, New Albany, Ind.

NEW ALBANY, VIEW OF KNOBS. This postcard shows one of the many conical hills that line southern Indiana a few miles north of Louisville and the Ohio River. They are thought to have been formed during the last Ice Age. The knobs contain rich soil, and in southern Indiana, they have become desirable places for residential development. Northwest of New Albany, the town of Floyds Knobs recognizes the significance of this geographic feature.

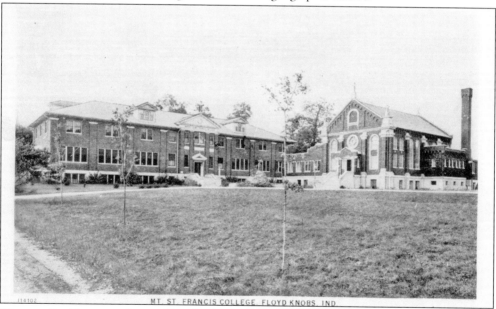

MT. ST. FRANCIS COLLEGE, FLOYD KNOBS, IND.

MOUNT ST. FRANCIS. Located in Floyds Knobs, Mount St. Francis is a religious community operated by the Conventual Franciscan order. Joseph and Mary Anderson donated 400 acres of land to the order in 1885, and by 1910, a seminary was established under the name of Mount St. Francis College. The seminary closed in 1975, but the facility remains a popular place for conferences and retreats. In recent years, an artists' community, the Mary Anderson Center, has been situated there.

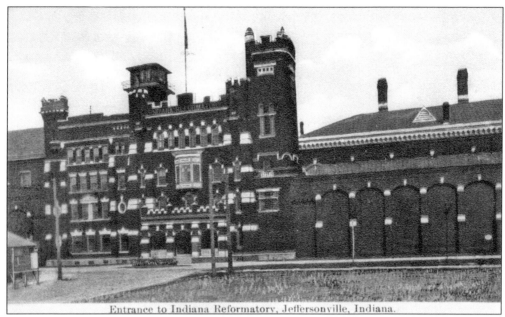

Entrance to Indiana Reformatory, Jeffersonville, Indiana.

Indiana Reformatory Sup't Res. foreground,
Jeffersonville, Ind.

INDIANA STATE REFORMATORY.
The Indiana State Reformatory
in Clarksville, known as Indiana
(or State) Prison South until 1897,
had been part of the Indiana prison
system since 1847 when it was moved
from Jeffersonville. Fire destroyed a
large part of the facility in 1918, and
in 1920, the property was sold to the
Colgate-Palmolive-Peet Company,
which made toothpaste, soap, and
other products there until 2008.

INDIANA STATE REFORMATORY.
A major remodeling, designed to
reduce the number of prisoners
escaping, took place in about 1887
to the castle-like exterior of the
prison. Louisville architect Arthur
Loomis, who lived in Jeffersonville
at the time, was responsible for the
remodeling, which included new
brick exterior walls and an entrance
gate and watchtower, features that
can be seen in both postcard views of
the prison.

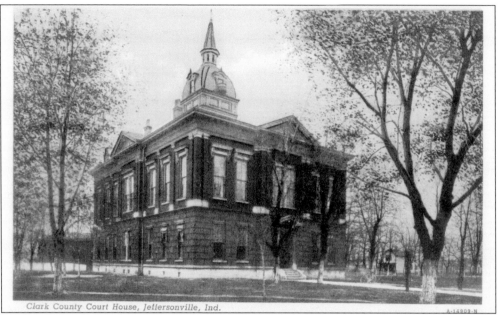

Clark County Court House, Jeffersonville, Ind.

A-14303-N

OLD COURTHOUSE, JEFFERSONVILLE. This county courthouse, built in 1878, was located on New Market Street (now Court Avenue) between West Street and Mayo Avenue. Lightning in the 1930s destroyed the cupola and spire, and the entire building was torn down in 1970 after a new one was constructed just east of it.

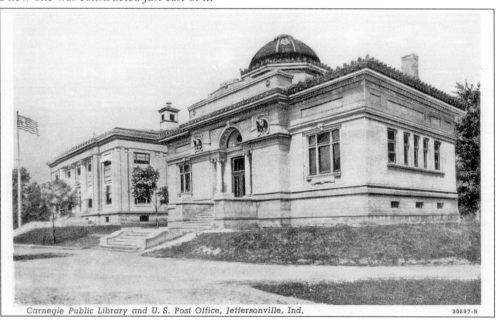

Carnegie Public Library and U. S. Post Office, Jeffersonville, Ind.

30897-N

POST OFFICE AND LIBRARY IN WARDER PARK, JEFFERSONVILLE. Warder Park is a small park named for former Mayor Luther F. Warder. It is located north of Court Avenue between Spring and Wall Streets. The Jeffersonville Township Public Library, popularly known as the Carnegie Library, was built at the north end of the park in 1900; the post office followed in 1912. After new facilities were constructed in the 1950s, the two buildings became part of the Indiana University Southeast campus until the university moved to New Albany in 1973.

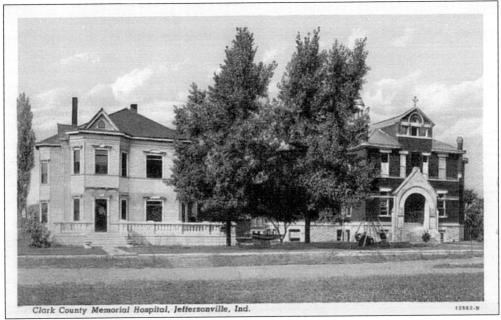

Clark County Memorial Hospital, Jeffersonville, Ind.

12582-N

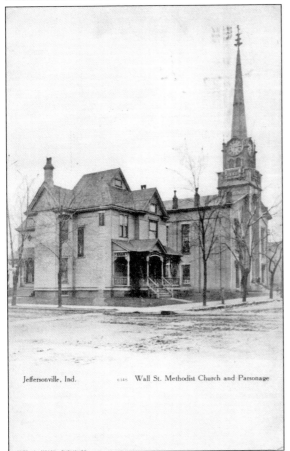

Jeffersonville, Ind. Wall St. Methodist Church and Parsonage

CLARK COUNTY HOSPITAL. Mercy Hospital, a Catholic institution, was a Jeffersonville hospital and sanitarium located at Twelfth Street and Missouri Avenue from 1897 until about 1908. In 1920, the town had no hospitals, so when the Jeffersonville Rotary Club was chartered that year, it worked with World War I veterans to raise money to buy and renovate the Mercy Hospital building. The effort was successful, and the new facility shown here opened in 1922.

WALL STREET METHODIST CHURCH, JEFFERSONVILLE. This church was erected between 1859 and 1865 along with a parsonage next door. Shortly after 1900, the steeple was deemed unsafe and removed, and a small bell tower was built in its place. Stained glass windows were installed in 1904 along with a forced-air heating system. A fire in February 1979 destroyed the church, but the congregation rebuilt on the same site.

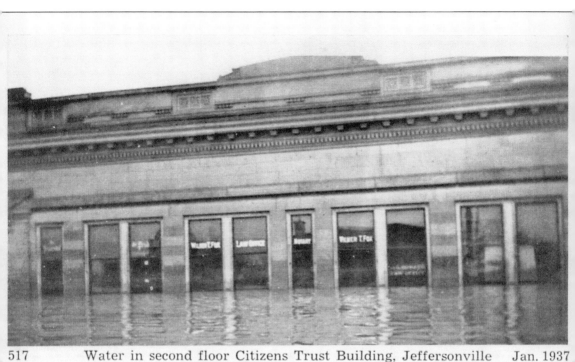

517 Water in second floor Citizens Trust Building, Jeffersonville Jan. 1937

1937 FLOOD, JEFFERSONVILLE. No town in the greater Louisville area suffered more from the January 1937 flood than Jeffersonville, where an estimated 95 percent of the homes and commercial buildings were inundated. This postcard view shows the flood reaching the second story of the venerable Citizens Bank, located at Spring Street and Court Avenue. The bank was designed by Arthur Loomis and opened in 1907. At its peak, the flood submerged Spring Street in downtown Jeffersonville to a depth of 22 feet.

FURTHER READING

Anderson, James C., and Donna M. Neary. *Louisville*. Charleston, SC: Arcadia Publishing, 2001.

Barksdale, David, and Robin Davis Sekula. *New Albany in Vintage Postcards*. Charleston, SC: Arcadia Publishing, 2005.

Bell, Rick. *The Great Flood of 1937*. Louisville: Butler Books, 2007.

Blasi, Gene. *Postcard Views of Louisville*. Louisville: n.p., 1994.

Darst, Stephanie. *One Hundred Kentucky State Fairs: A Pictorial History*. Louisville: Kentucky State Fair Board, 2004.

Central Kentucky chapter, American Institute of Architects. *Reprint of the catalogue of the first exhibition, 1912*. Bedford, MA: Applewood Books, 2008.

Dunn, Maurice. *Camp Zachary Taylor Souvenir*. Louisville: Lamberton Service Bureau, 1917.

Johnson, Leland R., and Charles E. Parrish. *Triumph at the Falls: the Louisville and Portland Canal*. Louisville: U.S. Army Corps of Engineers, 2007.

Kentucky: A Guide to the Bluegrass State. New York: Harcourt Brace and Company, 1939.

Kleber, John E., ed. *Encyclopedia of Louisville*. Lexington: University Press of Kentucky, 2001.

Nokes, Garry. *Jeffersonville, Indiana*. Charleston, SC: Arcadia Publishing, 2003.

Riebel, R. C. *Louisville Panorama*. Louisville: Liberty National Bank and Trust Company, 1954.

Sarles, Jane. *Clarksville, Indiana*. Charleston SC: Arcadia Publishing, 2001.

Thomas, Samuel W. *Louisville Since the Twenties*. Louisville: *Courier-Journal*, 1978.

———. *Views of Louisville Since 1766*. Louisville: *Courier-Journal*, 1971.

Yater, George. *Two Hundred Years at the Falls of the Ohio: a History of Louisville and Jefferson County*. Louisville: Filson Club, 1987.

INDEX

DISCOVER THOUSANDS OF LOCAL HISTORY BOOKS
FEATURING MILLIONS OF VINTAGE IMAGES

Arcadia Publishing, the leading local history publisher in the United States, is committed to making history accessible and meaningful through publishing books that celebrate and preserve the heritage of America's people and places.

Find more books like this at
www.arcadiapublishing.com

Search for your hometown history, your old stomping grounds, and even your favorite sports team.

Consistent with our mission to preserve history on a local level, this book was printed in South Carolina on American-made paper and manufactured entirely in the United States. Products carrying the accredited Forest Stewardship Council (FSC) label are printed on 100 percent FSC-certified paper.

MADE IN THE